MICHELANGELO
and his art

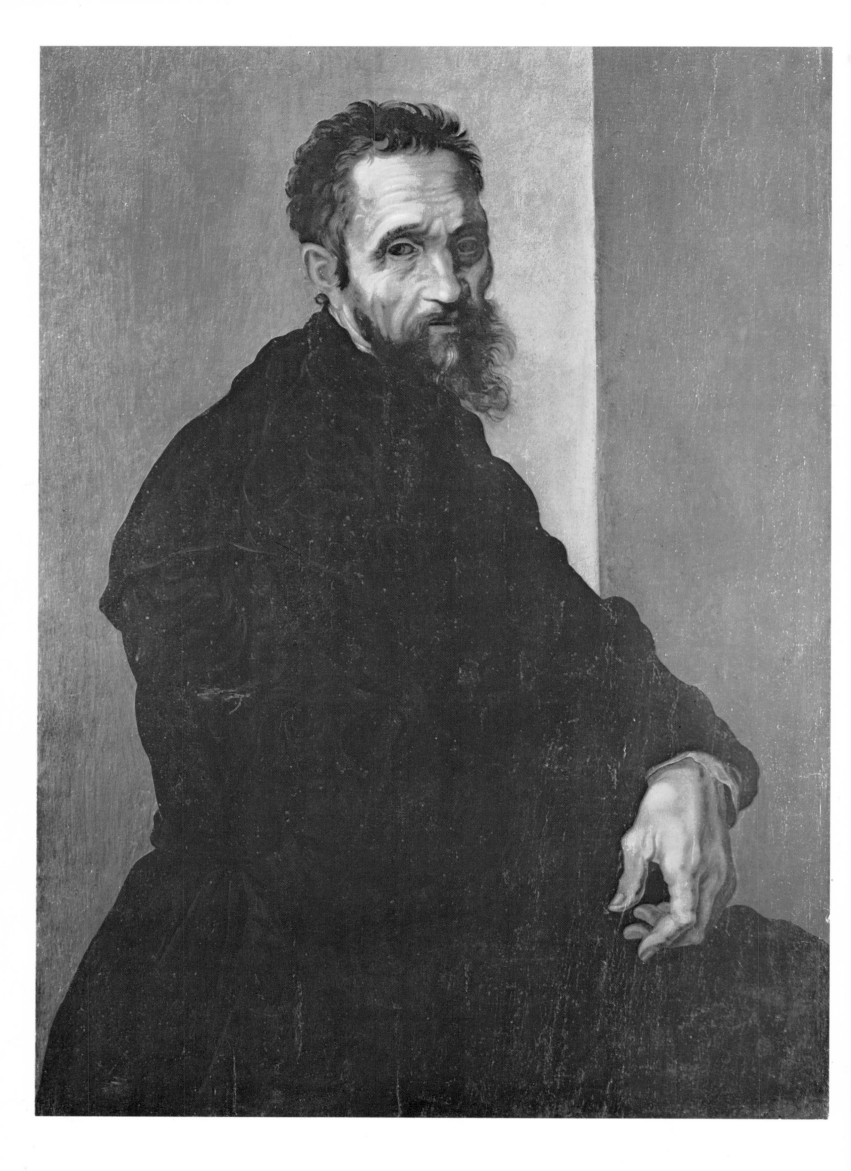

MICHELANGELO
and his art

John Furse

Galahad Books New York

Frontispiece
A portrait of Michelangelo (1475–1564),
attributed to Jacopino del Conto but
possibly a self-portrait. It was painted
around 1540, when Michelangelo was 65,
and clearly shows his sadness and weariness.
Casa Buonarroti, Florence.

Published by Galahad Books
a division of A & W Promotional Book Corporation
95 Madison Avenue, New York, NY 10016

Library of Congress Catalog Card No. 74-78013
ISBN 0-88365-249-8

© Copyright The Hamlyn Publishing Group Limited 1975

Phototypeset in England by
Filmtype Services Limited, Scarborough
Printed in Spain by
Mateu Cromo Artes Gráficas S.A., Madrid

Contents

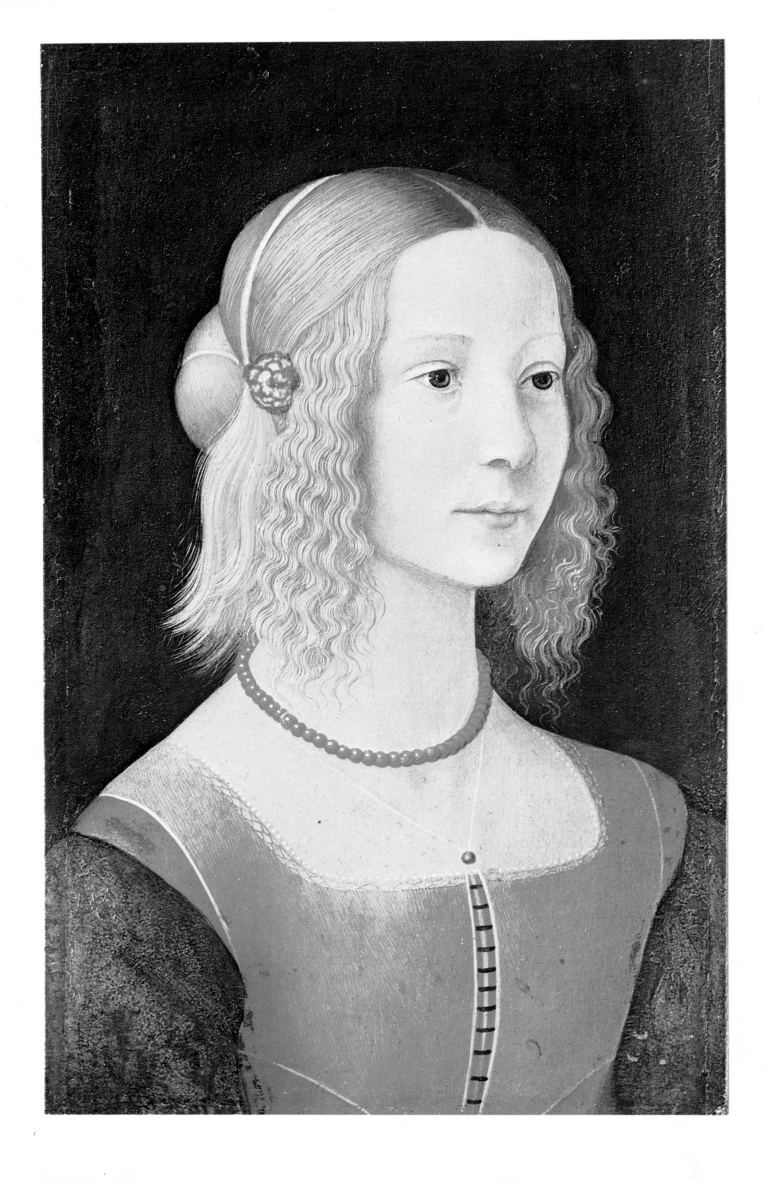

6

Beginnings

Michelangelo di Lodovico di Buonarroti was born on 6 March 1475 in the small Tuscan town of Caprese some forty miles from Florence. He died, in Rome, on 18 February 1564, one month short of his eighty-ninth birthday.

Sculptor, painter, architect and poet—the archetypal 'genius'—he was, above all other things, what the Florentines called 'a master of live stone'. Obsessed by work, he epitomises the romantic conception of the artist. Unsociable, untidy, caring little for personal comforts, he was a man of enormous energy, and known by his contemporaries as *Il Terribile*. Rejecting all the assumptions of the Renaissance, he revolutionised all he touched, and his style, an intermingling of sweetness and strength, is unique in the history of art.

The second son of Lodovico Buonarroti, then resident Florentine Commissioner in Caprese—a post that sounds far more impressive than it really was—his early years were hardly settled. Less than a month after his birth, his impoverished family returned to Florence and he went to live with a foster-mother, the wife of a stone-cutter, in the nearby village of Settignano. His mother died when he was six and some four years later he went back to live with his father, who had by this time remarried.

At school he met Francesco Granacci, who was six years older than himself and already a painter and working in the studio of Domenico Ghirlandaio. In 1488 this early and deep friendship led to his being formally placed, not without some parental opposition, as an apprentice with the 'sweet and placid' Ghirlandaio, when Michelangelo was thirteen. It was intended that he should stay for three years specifically to learn the art of painting. Considered by some to be a 'Florentine mediocrity', Domenico Ghirlandaio (1449–94) was an accomplished fresco painter with a certain understanding of light and movement, but lacking any real passion. According to Bernard Berenson, Domenico had 'almost no genuine feeling for what makes painting a great art'. He was, however, a popular painter of bright colours and pretty faces, and his portraits are lifelike and not without a certain charm.

Plate 1
Portrait of a Girl
Studio of Domenico Ghirlandaio
(1449–1494)
c. 1450
Wood, painted surface
17$\frac{3}{8}$ × 11$\frac{1}{2}$ in (44.1 × 29.2 cm)
National Gallery, London

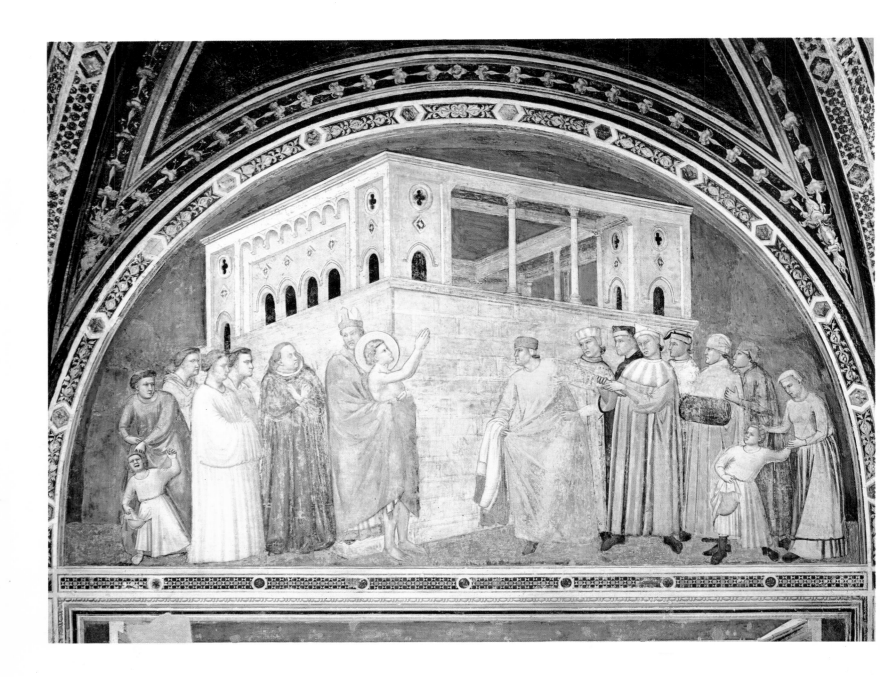

Later in life, Michelangelo tried to suppress the fact that he had served any kind of apprenticeship, but by then he had become very much the 'fine artist', and his attitude is not to be taken necessarily as an implied criticism of Ghirlandaio. It was, in fact, while he was with Ghirlandaio, that Michelangelo drew from the frescoes of Giotto and Masaccio, and where he first began to show the true character of his art.

Without the Renaissance of Masaccio and Donatello and the earlier achievements of Giotto and Giovanni Pisano, he would have been unable to work in his own particular way. Though an artist of impulse and passion, Michelangelo was the last of the Florentines to worship the classical order of the ancient world. He is best approached, then, through his predecessors: Giotto (1266/67–1337), the almost legendary father-figure of Florentine

Plate 2
St Francis of Assisi Renouncing his Inheritance
Giotto (c. 1266–1337)
c. 1320
Fresco
10 ft 6 in × 5 ft 6 in (314 × 162 cm)
Bardi Chapel, Sta. Croce, Florence

Plate 3
St Peter Healing the Sick by the Fall of his Shadow
Masaccio (1401–1428)
1427
Fresco
7 ft 6½ in × 5 ft 3¾ in (230 × 162 cm)
Brancacci Chapel, Sta. Maria del Carmine, Florence

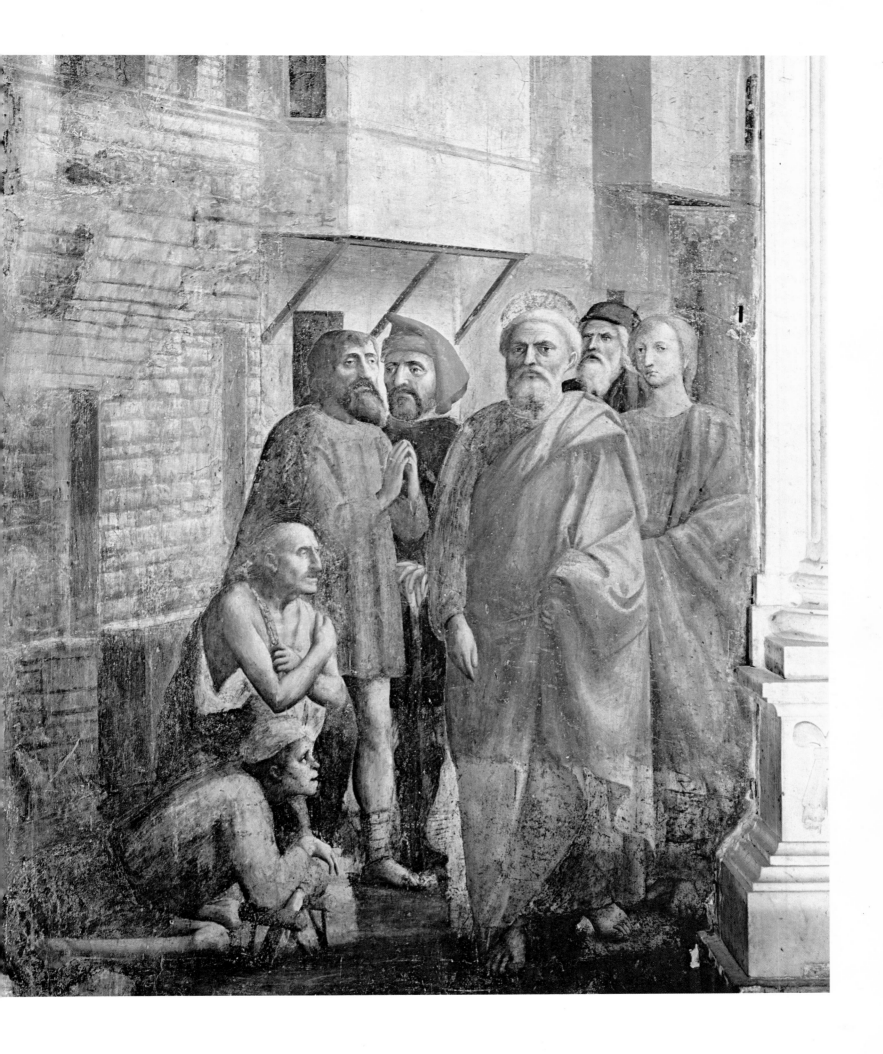

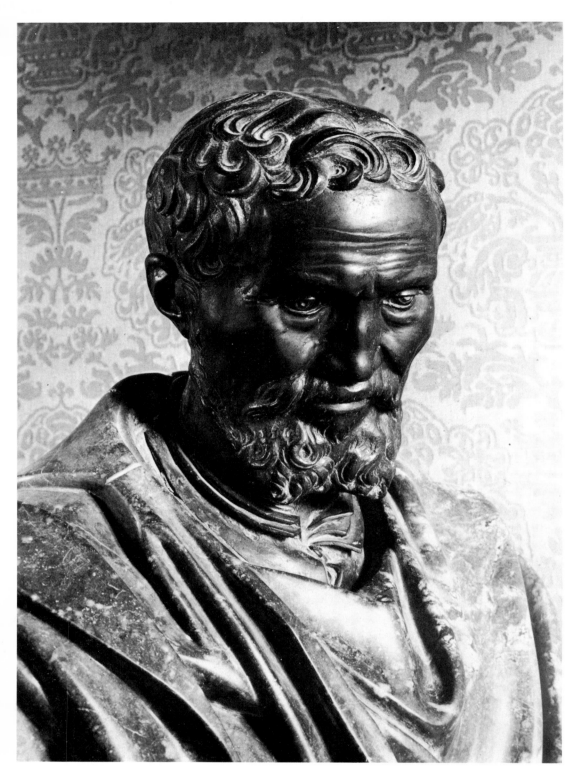

Plate 4
Bust of Michelangelo
Daniele da Volterra (1509–1566)
Bronze cast from marble
Capitoline Museum, Rome

art, and generally regarded as the founder of modern painting, who gave his figures such solidity and life-like conviction, and Masaccio (1401–28)–'Giotto reborn'–a master of sober narrative power and economy of form.

In 1489 Michelangelo left the Ghirlandaio workshop and entered the school for sculptors supervised by Bertoldo di Giovanni, a pupil of Donatello, to whom he had been introduced by his friend, Francesco Granacci.

Situated in the Medici Gardens, it was under the direct patronage of Lorenzo de' Medici–'The Magnificent'. Here he was able to

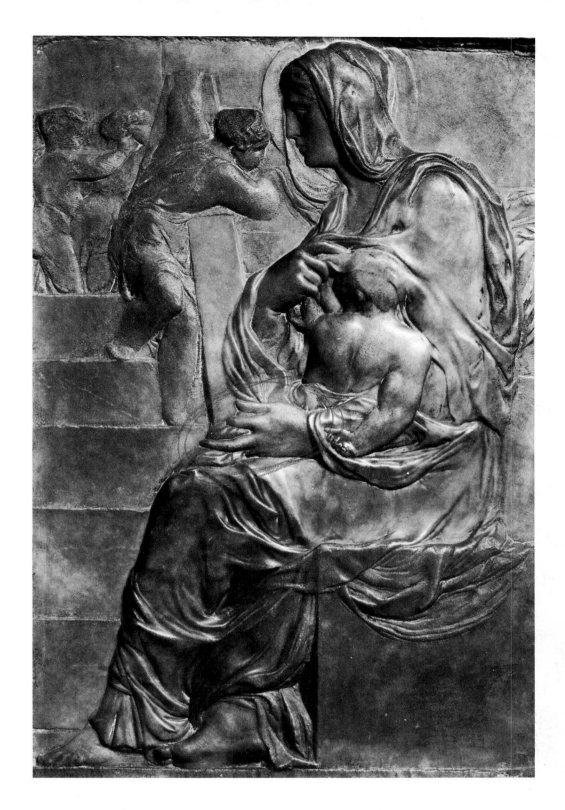

Plate 5
Madonna of the Stairs
c. 1491
Marble relief
22 × 15¾ in (55 × 40 cm)
Casa Buonarroti, Florence

study the Classical sculpture, as well as the other curiosities in Lorenzo's collection. But perhaps of even more importance, it brought him into contact with some of the brightest minds of the day. His abilities were soon recognised and he was invited to live in the Medici Palace, where he was well treated as one of the household. He continued to draw from the Masaccios in the Brancacci Chapel and it is said that it was here that the young sculptor, Pietro Torrigiano, so incensed by Michelangelo's arrogance, hit him hard in the face and broke his nose. As Walter Pater rather picturesquely puts it: 'And it was at this time that in a

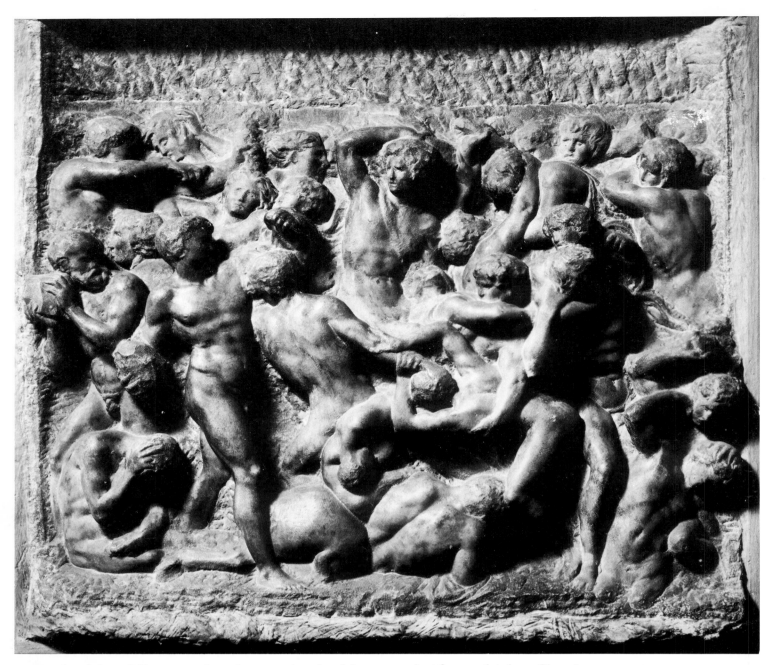

quarrel with a fellow student he received a blow on the face which deprived him forever of the comeliness of outward form'. Whether it also marked his personality is a matter for conjecture.

While with Bertoldo, Michelangelo carved the so-called *Madonna of the Stairs* (plate 5), a small marble low-relief, which attempted to describe the subtle relationship between mother and child. Though very much a minor work and in the manner of Donatello, it hints at much of what is to come with its respect for the material and the handling of the delicate drapery falling across the body beneath.

Far more interesting is *The Battle of the Centaurs* (plate 6), which shows an early interest in a theme involving a number of nude figures in dynamic relationship with one another. He himself kept it in his possession all his life and obviously considered it the best of his early works. It is not clear whether the figures in the seemingly endless mass of bodies are male or female, which are the

Plate 6
Battle of the Centaurs
c. 1492
Marble relief
$33\frac{1}{4} \times 33\frac{5}{8}$ in (84.4 × 85.4 cm)
Casa Buonarroti, Florence

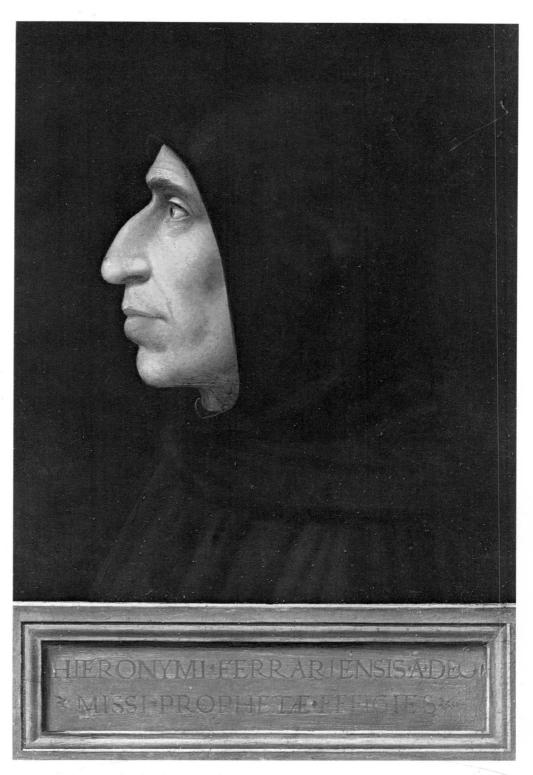

Plate 7
Portrait of Girolamo Savonarola
Fra Bartolommeo della Porta (1475–1517)
c. 1500
Wood, painted surface
18½ × 12 in (47 × 31 cm)
Museo di San Marco, Florence

centaurs and which the *lapiths*, but there is much well-defined modelling and broad detail and the work very much anticipates the later *Battle of Cascina*.

On Lorenzo's death, in 1492, Michelangelo returned to his father's house, but Lorenzo's successor, his son Piero, soon invited him back again to live in the palace. Piero de' Medici, soon to be known as 'The Unfortunate', proved to be not only an inadequate pope but a disappointing patron. The sole commission he offered the sculptor was to ask him to make a statue of snow – a snowman!

He managed to carve a larger than life-size figure of *Hercules*, which has been lost for some time, and also a *Wooden Crucifix*

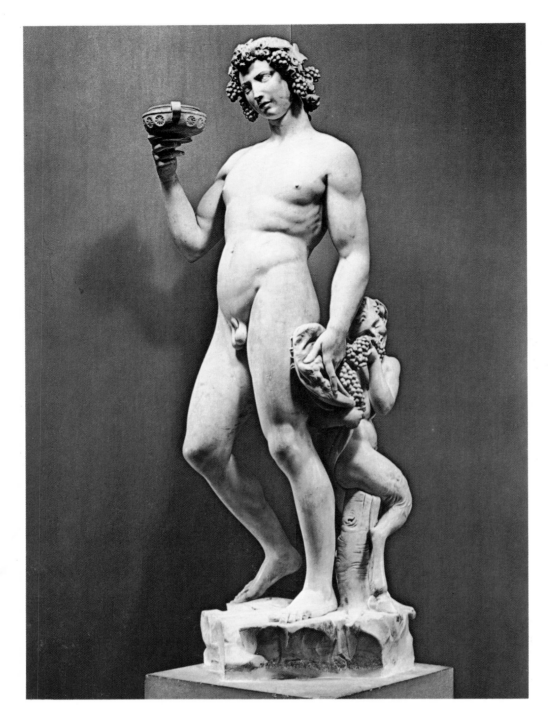

Plate 8
Bacchus
c. 1497
Marble
Height 6 ft 8 in (203.2 cm)
Museo Nazionale (Bargello), Florence

which he made for the Prior of Santo Spirito, who had given him permission to dissect the corpses of those who had died in the monastery hospital. This work he carried out in great secrecy, and as a result there are no surviving anatomical studies.

The crucifix was also lost, but was then rediscovered in 1962 and can now be seen in the Casa Buonarroti in Florence. It is a sensitive piece of carving, intended to be seen from below; the slender body of Christ, legs crossed, hardly seems to be attached to the cross, suggesting the manner of the later drawings.

Sensing the growing unpopularity of 'The Unfortunate', Michelangelo left Florence for Bologna later, moving to Venice and then back to Bologna, where he stayed for just over a year. Whilst in Bologna, he carved two small marble figures,

St Petronius and *St Proculus*, and a small *Angel with a Candlestick* intended for the incomplete *Tomb of St Dominic*.

Eventually Piero was banished from Florence and a government was formed under the somewhat gloomy influence of Savonarola. Later that year Michelangelo returned to Florence.

Girolamo Savonarola (1452–98) (plate 7) was a reforming monk from Ferrara, an intellectual preacher and eventual martyr to his beliefs. Speaking from a profound knowledge of the scriptures, he delivered his hell-fire, prophetic sermons in his capacity of Prior of San Marco, establishing an unrivalled influence over Florentine thought. He succeeded in filling the churches with his cries for 'Christ King in Florence', and this, together with chanting processions, were the outward signs of a genuine religious revival: 'Never was so much virtue and religion in Florence as in his day'.

Michelangelo was a devout reader of his works, though it is hard to imagine him totally agreeing with such sentiments as, 'In houses where young maidens dwell it is dangerous and improper to retain pictures wherein there are undraped figures', and perhaps feeling himself unlikely to prosper in Savonarola's Florence, he left for Rome, for the first time, in the spring of 1496.

Though the part he played in politics was small, Savonarola's fall was precipitated by political entanglement. He was excommunicated in 1497, and the tide of religious fervour waned. One of Florence's greatest teachers, he was tried for heresy and, on 23 May 1498, was burnt at the stake.

While in Rome, living and working in the house of the rich banker, Jacopo Galli, and 'at times in a great passion for many reasons that happen to him who is away from home', Michelangelo carved his first major work – the controversial *Bacchus* (plate 8), depicting a soft, plump, drunken adolescent rather than the traditional god Bacchus who, though he caused rivers of wine to flow, was never himself drunk.

The flowing lines of the god's smooth and fleshy body reflect the flow of the wine, producing an effect of sensuous depravity. Vasari was the first to comment on the hermaphroditic elements in the figure: 'A marvellous blending of both sexes–combining the slenderness of youth with the round fullness of woman', and when the question of the sculptor's homosexuality arises, it is almost instinctively to the *Bacchus* that we turn.

Always revolted by what he considered sinful, Michelangelo seems to be moralising and gives us an abstraction rather than an illustration. This is the importance of the *Bacchus* in the development of his art. Right from the start he is concerned with what lies beneath the surface.

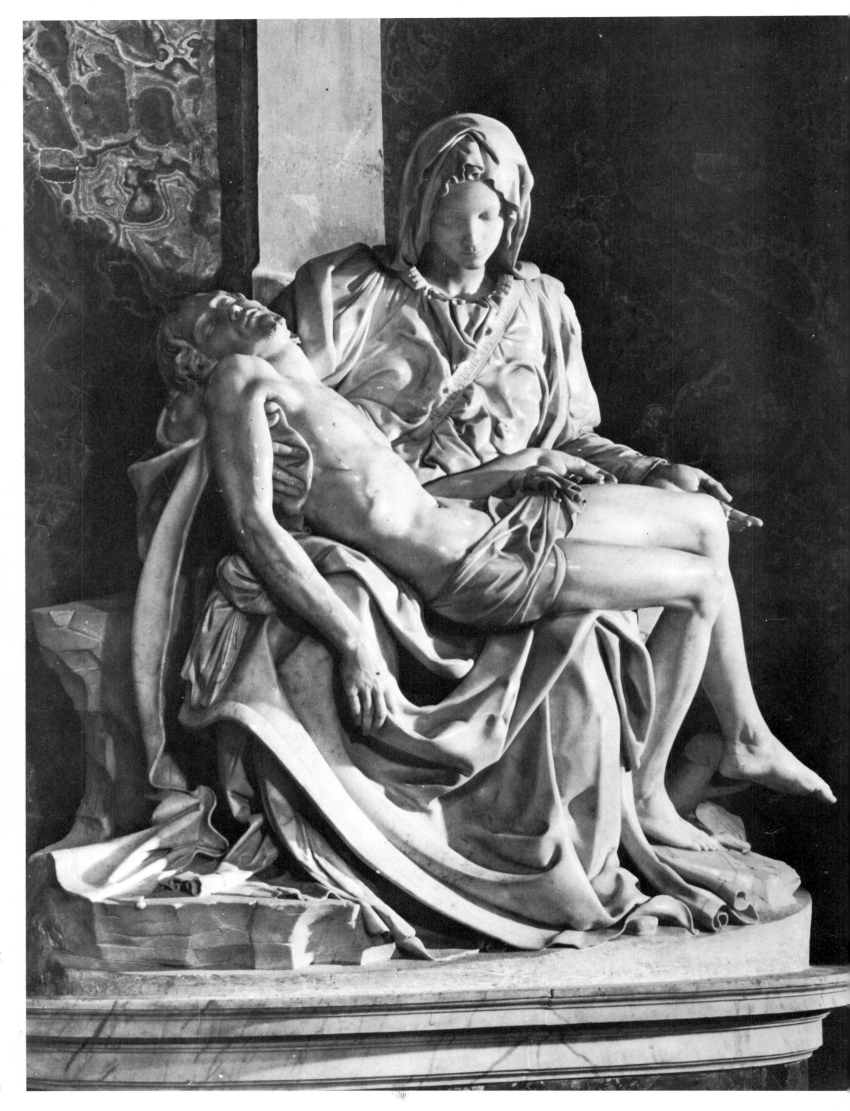

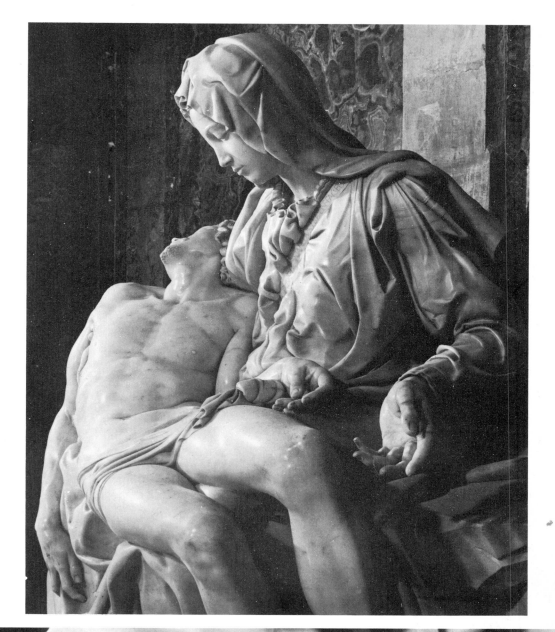

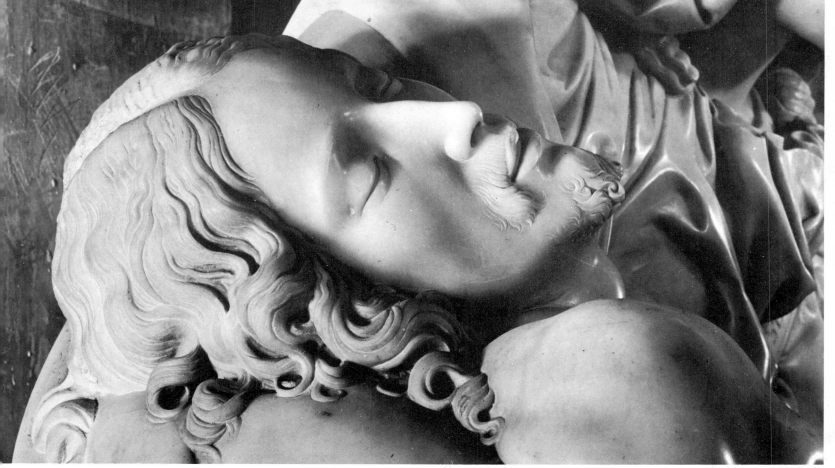

17

Early Years

The two works that follow the *Bacchus*—the so-called *Rome Pietà* and the *David*—are really the first products of his maturity.

The Rome Pietà

According to Galli, who obtained the commission, it was 'the most beautiful marble statue in Rome and no living artist could better it', and it certainly is a most remarkable piece of carving. Deliberately beautiful and full of fine detail, it is very much a High Renaissance group, with all the finely balanced tenderness and serenity we associate most readily with the perfection of Raphael. Vasari wrote: 'It staggers belief that the hand of an artist could have executed this inspired and admirable work so perfectly and in so short a time. It is certainly a miracle that a formless block of stone could ever have been reduced to a perfection that nature is scarcely able to create in the flesh'.

In 1498 Michelangelo made the first of his many visits to the marble quarries of Carrara—'solemn with the stillness of evening'—to supervise the quarrying of the block, and the piece was completed in the spring of 1499.

Mary sits with Christ's limp body lying across her lap (plate 10), just managing to support her dead son and seemingly gently drawing him towards her. It is a work of profound pity.

Again to quote Vasari: 'No portrayal of a corpse can be more realistic, yet the limbs have a rare beauty, and the muscles, veins and nerves stand out to perfection from the bone structure. The face bears an expression of infinite tenderness, and all the joints, especially those that link the arms and legs to the body, have a wonderful harmony. So superb is the tracery of veins beneath the skin that it is a source of never-ending wonder how an artist could achieve such a divine beauty.' Michelangelo is able to evoke horror without the direct use of horrors. During his dissections he must 'have lain over the lifeless body when all was at length quiet and smoothed out. After death it is said that traces of slighter and more superficial dispositions disappear; the lines become more simple and dignified, only the abstract lines remain in great indifference.'

This is a work of great compassion from a young man still in his

Plate 12
David
1501–4
Marble
Height 16 ft 10 in (410 cm)
Accademia, Florence

18

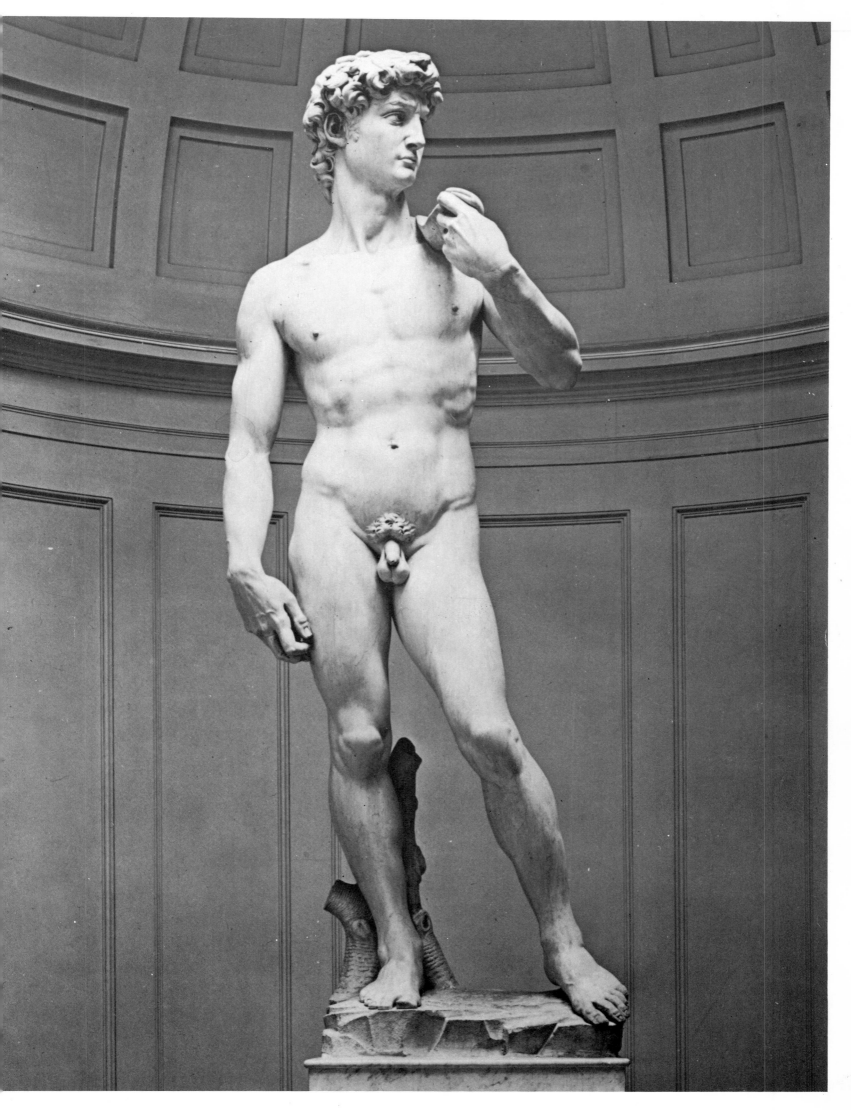

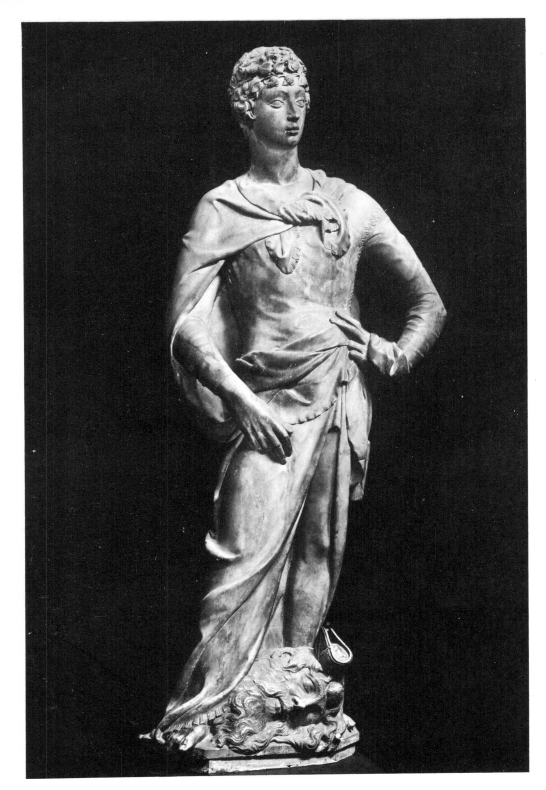

Plate 13
David
Donatello (*c.* 1386–1466)
1408–9
Marble
Height 6 ft 3½ in (191.8 cm)
Museo Nazionale (Bargello), Florence

early twenties; the material is handled with great skill, both in the extremely delicate treatment of the drapery and in the minute detail of toe and finger-nail.

Condivi recorded that contemporary critics objected to what they called the unrealistic treatment, on the grounds that there is no measurable difference in age between Christ and the Madonna, to which Michelangelo is said to have replied: 'Do you not know that chaste women maintain their freshness far longer than the unchaste?' This then is the mood of the *Pietà*.

Plate 14
David
Gianlorenzo Bernini (1598–1680)
1623
Marble
Height 14 ft 6 in (442 cm)
Borghese Gallery, Rome

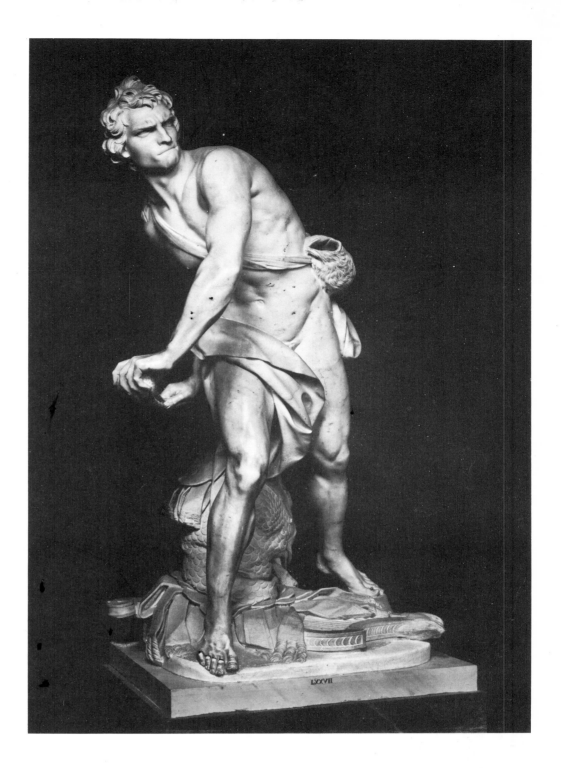

David

Standing some 17 feet in height, this immense nude figure (plate 12), often called 'The Giant', is very much a young man's masterpiece. Now in the somewhat rarified atmosphere of the Florence Accademia (a replica stands in its original setting, outside the Palazzo Vecchio), it is at once impressive and unhappy.

There is an awkwardness about the figure, a feeling of doubt. Proudly poised, we can sense the attraction for the sculptor, but he seems indecisive as to what he wants us to feel. His *David* belongs very much to the world of the spirit, halfway between the appealing youth of Donatello (plate 13) and the Baroque athlete of Bernini (plate 14).

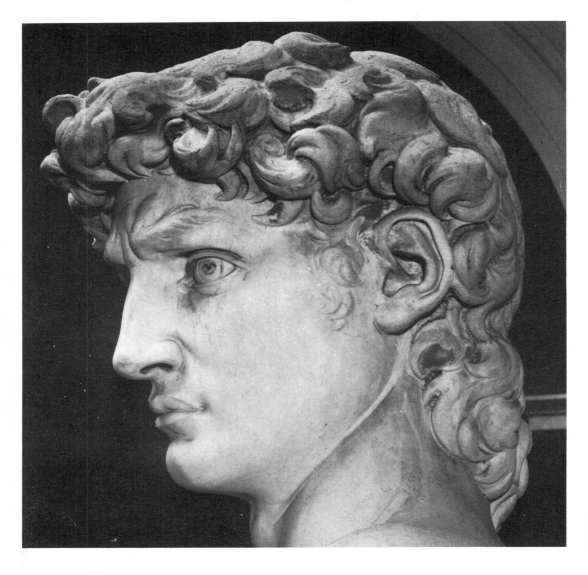

It was carved from a supposedly faulty block of marble owned by the Cathedral authorities who, on the sculptor's return from Rome in 1501, invited him to 'extract a figure of David' from it. He finished the work in 1504.

Michelangelo always saw carving as a form of extraction, believing that the greatest artist can have no conception which is not already within the stone.

The marble not yet carved can hold the form
Of every thought the greatest artist has,
And no conception can yet come to pass
Unless the hand obeys the intellect . . . (from *Sonnet XV*)

His task was merely to 'release the figure from its stone prison' – sculpture worked 'by force of taking away', and his method was simplicity itself.

In 1550 Blaise de Vignère wrote: 'I saw Michelangelo at work. He had passed his sixtieth year and although he was not very strong, yet in a quarter of an hour he caused more splinters to fall

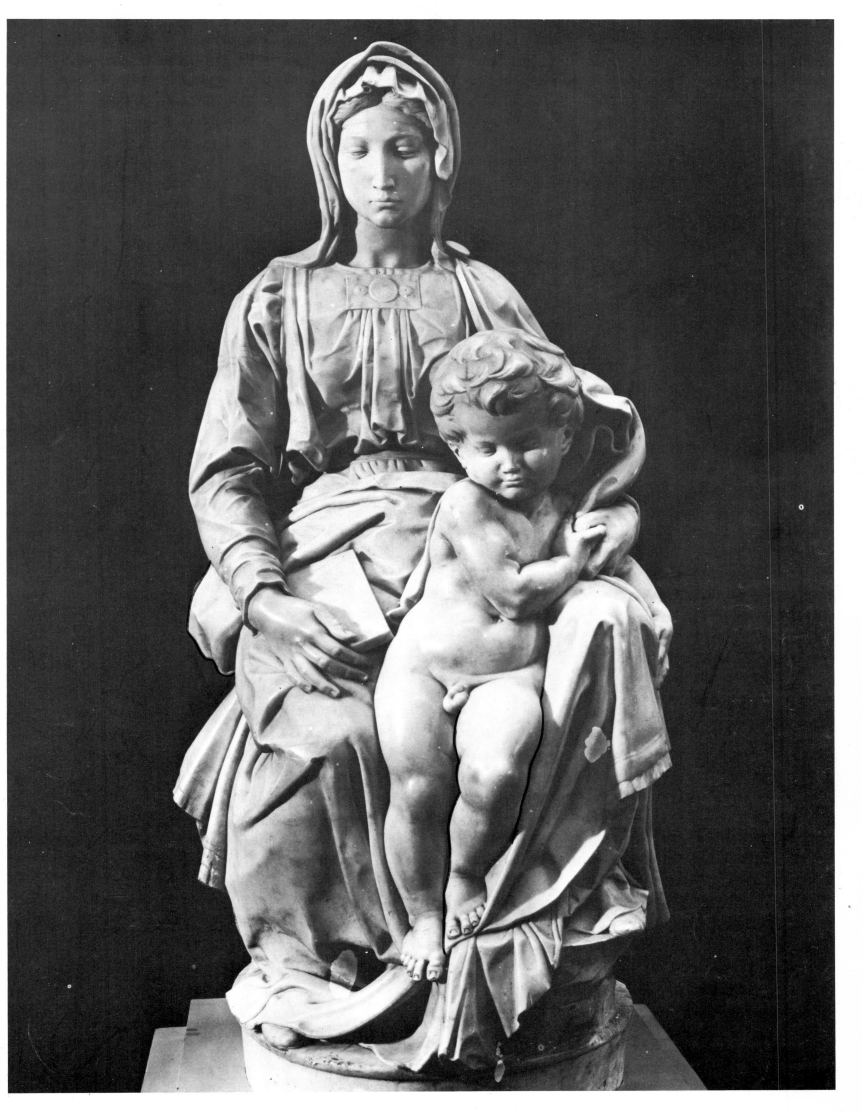

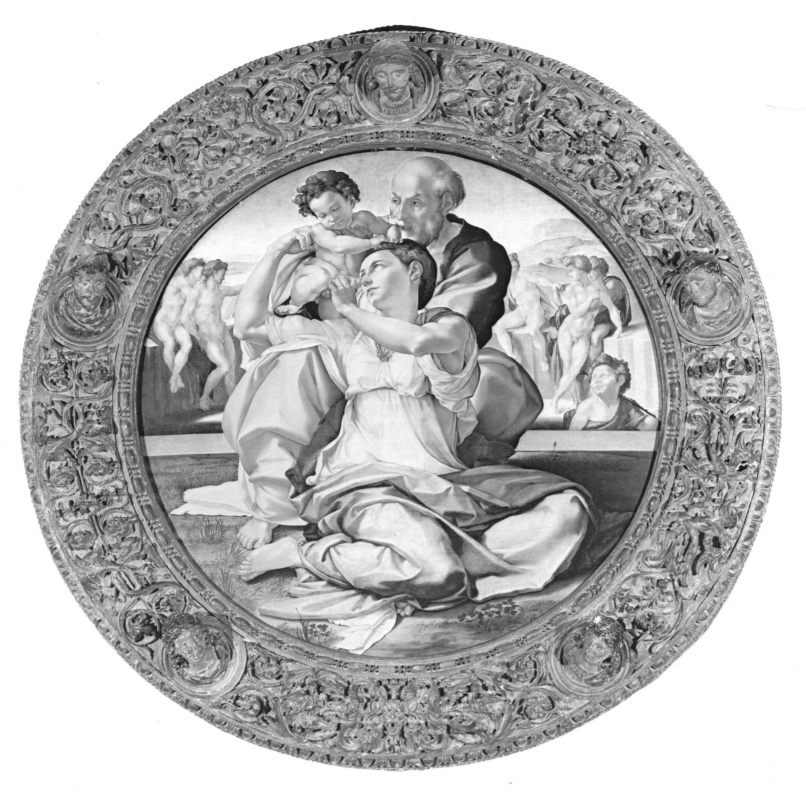

from a very hard block of marble than three young masons in three or four times as long. No one can believe it who has not seen it with his own eyes. And he attacked the work with such energy and fire that I thought it would fly into pieces. (It is said that in his carving he was ambidextrous.) With one blow he brought down fragments three or four fingers in breadth, and so exactly at the point marked, that if only a little more marble had fallen he would have risked spoiling the whole work.'[1] One can imagine the energy of the young Michelangelo some forty years earlier.

Plate 17
The Holy Family (The Doni Madonna)
c. 1503–4
Tempera on panel
Diameter 3 ft 11¼ in (120 cm)
The Uffizi Gallery, Florence

[1] Anthony Bertram, *Michelangelo*, Dutton-Vista 1964, p.20.

David stands ready, but with natural apprehension, for the fight against overwhelming physical odds. There is no turning back. Breaking away from the Renaissance ideal of moderation and harmony, Michelangelo had created his first hero, and there is little doubt that he had done it deliberately.

While he was finishing the *David*, and in the following year or so, Michelangelo produced a group of relatively minor works which, however, are not without their individual attractions.

Started before the *David*, but finished later, *The Bruges Madonna* (plate 16), originally intended for the altar of Siena Cathedral, is particularly pleasing. Considered by some to be partly the work of an assistant, it is nevertheless in the same vein as the *Pietà*, with its sensitive carving and air of contemplative sadness and, as such, must be taken to be the last of Michelangelo's strictly Renaissance works. Totally harmonious, the delicate, naturalistic treatment of the child, and the mother's touchingly protective hands, give the piece an undeniable charm, and it has none of the disturbance and doubt of his more mature style. For some unknown reason it was sold to the city of Bruges in 1506, where it now stands in the Cathedral.

The Pitti Madonna, unfinished and now in the Bargello in Florence, is a marble low-relief, the main interest of which is that the figure of the virgin, in retrospect, has something of the quality of the Sibyls in the Sistine ceiling.

The Taddei Madonna again is unfinished but this adds to its charm, as there is an air of sentimentality about the piece, which in a highly polished work might well be too much to bear. The Madonna is seen playing with the two children, and the Child Jesus, obviously frightened by the small bird held by John the Baptist, recoils in alarm. The mother is trying to calm him down.

The Holy Family, also called *The Doni Madonna* (plate 17), is interesting, mainly because it is the artist's only authenticated easel painting in tempera. As such, it has an important bearing on the Sistine Ceiling, particularly because of the frieze of nude figures painted into the background, which bear no true relation to the story depicted and seem to be pure whim on Michelangelo's part. The figures are strongly sculptural, fitting securely into their circular frame. Nor do they lack a certain psychological subtlety.

In 1503 the Signoria of Florence commissioned Leonardo da Vinci and Michelangelo to decorate the two long walls of the Council Chamber of the new Florentine Republic in the Palazzo Vecchio. Both paintings were to be some 20 feet high and over 50 feet wide. This grandiose project eventually came to nothing;

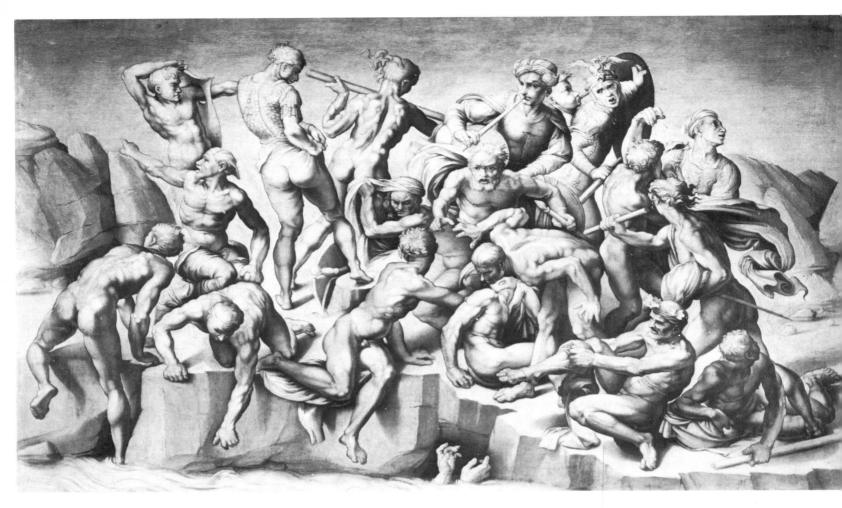

both cartoons remained unfinished and both are lost. The most plausible copy of Michelangelo's cartoon, a grisaille, is at Holkham Hall in Norfolk (England).

The Battle of Cascina (plate 18) is in fact not a battle scene at all, but shows an incident in the war of 1364 with Pisa, when some four hundred Florentine soldiers, bathing in the Arno, at Cascina, were surprised by the enemy.

The theme gave Michelangelo his first opportunity since the early *Battle of the Centaurs* to depict a crowd of male nudes in action – this time over life-size – and he obviously relished the chance to display his growing understanding of the energetic contortions of the moving human body. It was an excuse to show his virtuosity, and the drawing was highly praised.

Vasari wrote: 'The multitude of figures . . . some outlined with charcoal, some etched with strokes, some shadowed with the stump, some relieved with white-lead . . . The craftsmen of design remained astonished and dumbfounded, recognising the further reaches of their art revealed to them by this unrivalled masterpiece . . . Never in the history of human achievement was any product of a man's brain seen like to them in mere supremacy'.

From the copy it seems a rather contrived composition, though the explicit anatomical detail and general air of vigorous muscularity seem ideally suited to a concept of this proportion,

Plate 18
Copy of Michelangelo's Battle of Cascina
1542
Tempera on panel (grisaille)
30 × 51 in (76 × 129 cm)
Collection of the Earl of Leicester, Holkham Hall

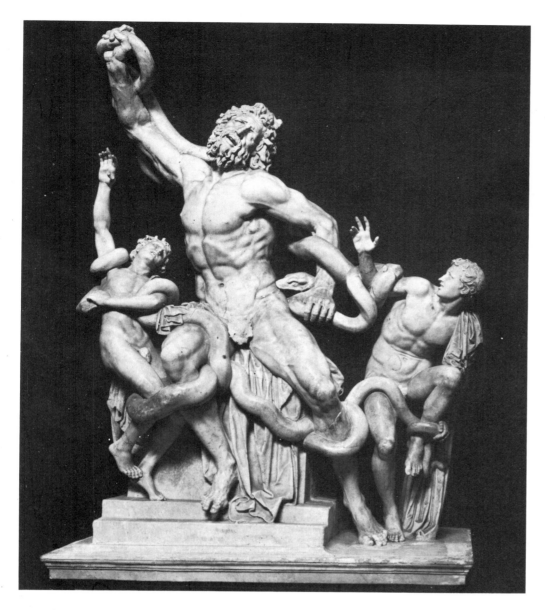

Plate 19
Laocoön and his Sons Assailed by Serpents
Agesander, Polydorus and Athenodorus of Rhodes
2nd–1st century BC
Marble
Height of Montorsoli restoration
7 ft 11¼ in (242 cm)
Pio Clementino Museum,
The Vatican, Rome

conceived, as it was, as an act of propaganda for the Republic.

In the spring of 1505 Michelangelo was called to Rome by Pope Julius II, a dynamic old aristocrat whose character was in so many ways like that of the sculptor himself. Full of energy, they fired each other's imaginations and it seemed almost predestined that they should work together. So began the most fertile years of the artist's life. So too began the saga of *The Tomb of Julius II* – the 'tragedy of the tomb' as Michelangelo called it – and the beginnings of the trials and tribulations that were to plague him for some forty fretful years.

The Tomb of Julius II

Intended to be free-standing, with approximately forty greater than life-size marble statues and several smaller reliefs, all to be completed in five years and destined for the new choir of St Peter's, the concept was typical of Julius – somewhat larger than life.

Michelangelo, however, saw it as an enormous challenge and one that would bring out in him all the latent qualities he knew he

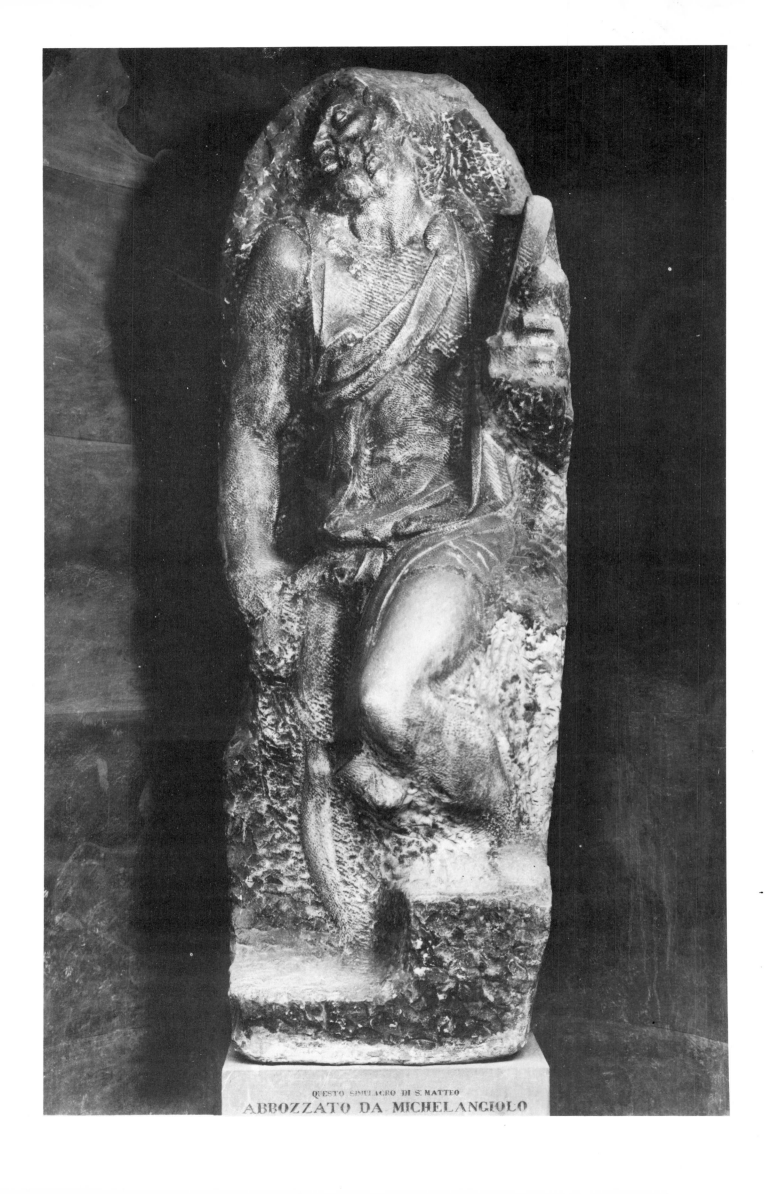

QUESTO SIMULACRO DI S. MATTEO
ABBOZZATO DA MICHELANGIOLO

28

possessed. He started on it immediately, travelled again to Carrara, and in January 1506 he started carving.

Also in January 1506 the *Laocoön* group (plate 19) was discovered in Rome, and by his own admission this discovery had a profound effect on his career. From now on, his ideal – his 'antiquity' – lay in the torment of the *Laocoön*.

The unfinished *St Matthew* (plate 20), originally intended for the tomb, is the first work to come under the new influence, as it struggles desperately to break free from the block that imprisons it. This figure has not only a strong physical presence, but also an undeniably abstract, almost spiritual, quality.

Michelangelo had always wanted to make violent muscular movement expressive of something more than mere physical strength and, until now, he had found few precedents in Classical art. To him the discovery of the *Laocoön* verged on the miraculous.

The group was found in a vineyard near S. Pietro in Vincoli where, somewhat ironically, the eventual *Tomb of Julius* now stands. Michelangelo could recognise the work immediately from Pliny's description: 'a work of art to be preferred above all else in painting and sculpture' – a description which had long fired the imagination of Renaissance artists, many of whom had made drawings suggesting what it might have been like. Now, there it was. The impact must have been enormous.

Suddenly Julius lost interest in his tomb and became more concerned with his scheme for the total reconstruction of St Peter's, and Michelangelo feeling himself slighted, left secretly for Florence, believing himself, as he put it, to be 'free of Rome'. This annoyed the Pope intensely and he ordered his return. Eventually, after dire threats, gentle persuasion and assurances of safety, Michelangelo appeared before him in Bologna, as he wrote later, 'with a rope around my neck'.

Unhappy in Bologna, he lived in 'great discomfort', sharing a bed with three others, and finding 'the heat intolerable and the wine bad'. To placate him, Julius commissioned a vast equestrian statue of himself to commemorate the capture of the city. Not only did this entail difficulties in the casting – in bronze – of so large a figure, but, when three years later, the Bolognese revolted, they melted down the statue to make cannon.

Early in 1508 Julius again called Michelangelo to Rome to discuss his plans for the painting of the Sistine Chapel ceiling and not, as he had hoped, to encourage him to start work on the tomb.

The Ceiling

The Sistine Chapel (plate 21), originally built for Pope Sixtus IV, is
a simple brick structure some 132 feet long and 44 feet wide.
Its maximum height is 68 feet and there is a shallow barrel-vault
flattened at the top. It was on this surface that Michelangelo was to
start work, and the first contract mentioned twelve apostles and
'ornament to cover the central section'.

He insisted that painting was not his profession–'nè io pittore'
('I am no painter')–and there is no doubt he was bitterly
disappointed by Julius's lack of interest in the tomb. It has even
been suggested that this disappointment at not being able to
continue his work as a sculptor led him, as it were, to transfer the
marble figures he had conceived for the tomb on to the ceiling,
and this is the reason for the rather obviously sculptural quality of
the work.

Michelangelo was in great distress and 'the greatest physical
labour'. He wrote: 'I have no friends of any kind and I don't want
any; I don't have the time that I can eat what I need: therefore
let me have no more trouble for I cannot stand another ounce.'
But by May he was already at work on preliminary drawings and
cartoons—no mean task in itself—and in January 1509 he started
painting.

Fresco painting, where the watercolour is worked freely and
quickly into drying plaster of Paris, requires a particular technique.
Only a limited number of colours can be used and these become
lighter when dry, and the painter has to allow for this. Only a
certain amount of work can be done in a day and a suitable area of
plaster must be prepared. The previously drawn cartoon is cut into
pieces and fastened on to the prepared ground and the outline
traced or 'pounced' through on to the painting surface. The edges
of the application can be clearly seen and it is possible to estimate
how much work was completed in any one day. Within these
limitations it is possible to work quite freely, the area drying in
about six weeks, when, if necessary, it is practical to work on it
again *a secco*, using colour mixed with size.

As far as we know, Michelangelo did all the actual painting

Plate 21
General View of the Sistine Chapel

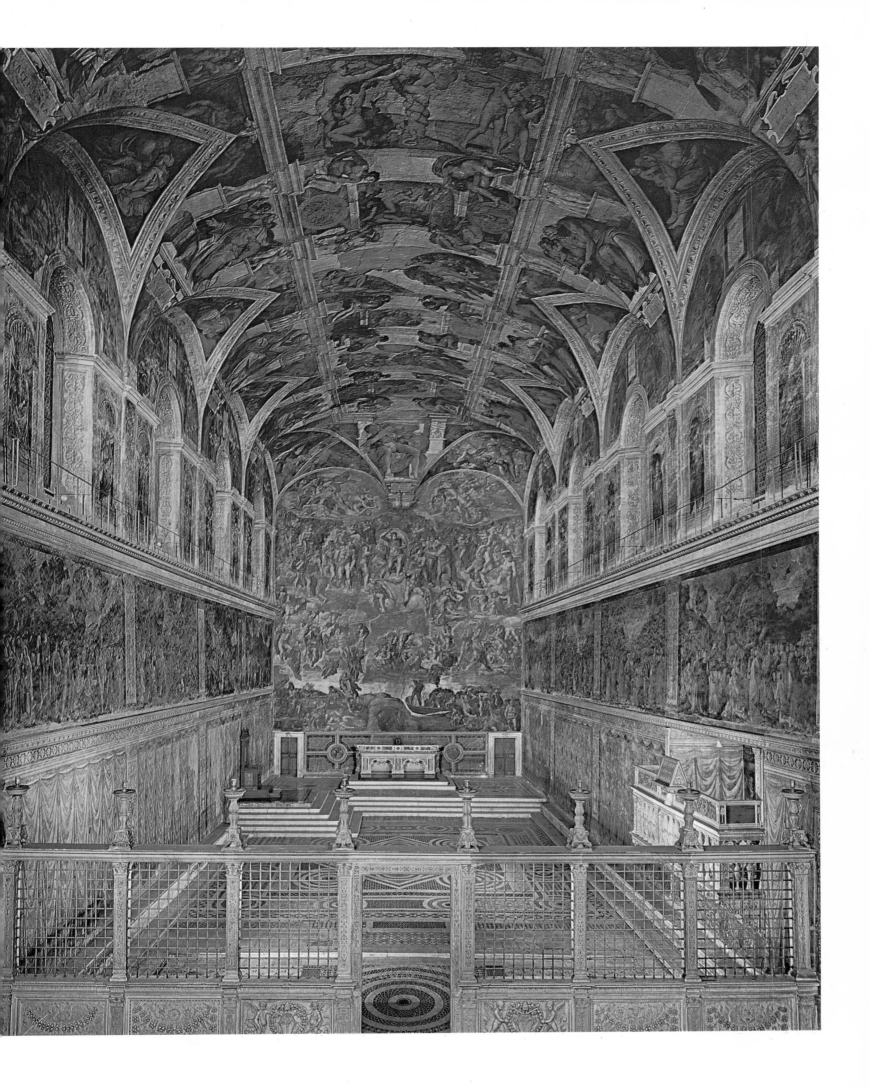

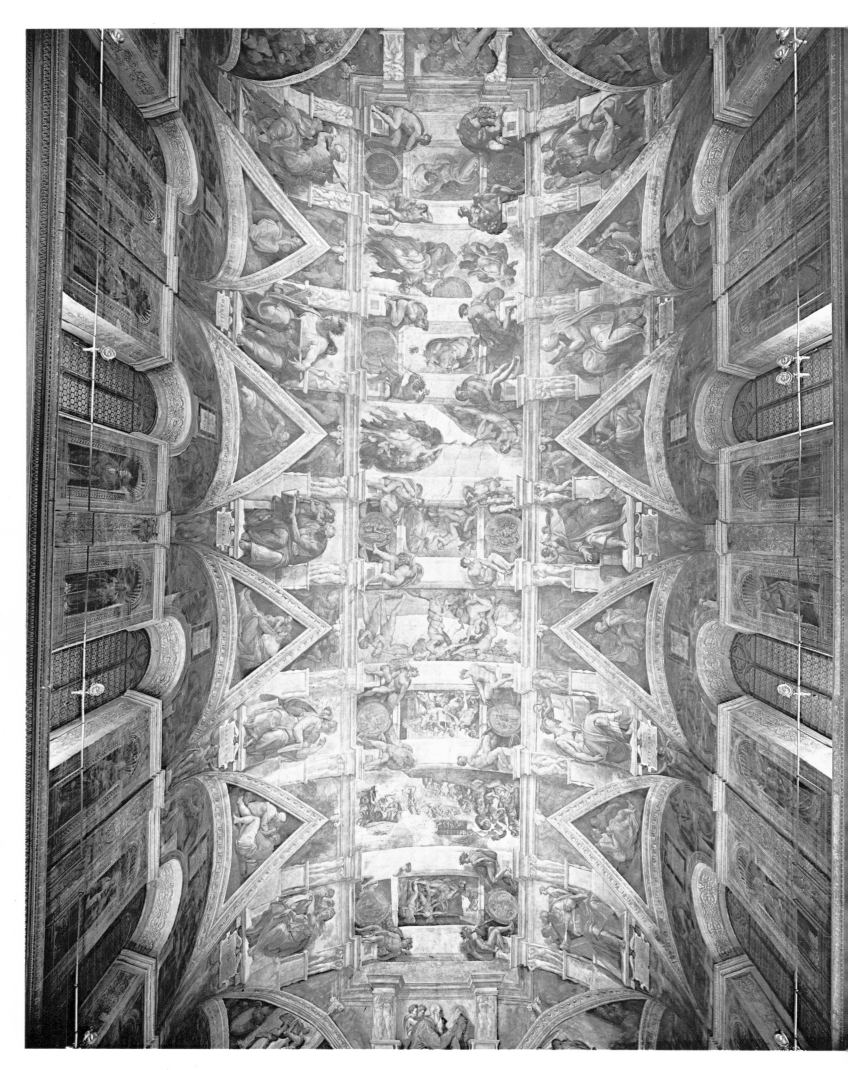

himself, working under the most apalling conditions and never really able to get far enough away from the ceiling to see clearly what he was doing. He described it later in a satyrical sonnet sent to Giovanni Pistoja.

To Giovanni da Pistoja on the Painting of the Sistine Chapel
Like cats from Lombardy and other places
Stagnant and stale, I've grown a goitre here;
Under my chin my belly will appear,
Each the other's rightful stance displaces.

My beard turns heavenward, my mind seems shut
Into a casket. With my breast I make
A shield. My brush moves quickly, colours break
Everywhere, like a street mosaic-cut.

My loins are thrust into my belly and
I use my bottom now to bear the weight
Of back and side. My feet move dumb and blind.
In front my skin is loose and yet behind
It stretches taut and smooth, is tight and straight.

I am a Syrian bow strained for the pull—
A hard position whence my art may grow.
Little, it seems, that's strong and beautiful
Can come from all the pains I undergo.
Giovanni, let my dying art defend
Your honour, in this place where I am left
Helpless, unhappy, even of art bereft. (*Sonnet V*)

Not only was this an unparalleled physical achievement, but it made him in a sense the first 'modern' painter, in that both the conception and the execution were the work of one man.

The Sistine Ceiling (plan 22 and plate 23)
Michelangelo chose for his theme nothing less than the creation of the world, the fall and punishment of Man; the ceiling contains some three hundred figures. Vasari wrote: 'Painters no longer need to seek new inventions, novel attitudes, clothed figures, fresh ways of expression, different arrangements, or sublime subjects, for this work contains every perfection . . .'. Joshua Reynolds said: 'His ideas are vast and sublime, his people are a superior order of beings; there is nothing about them, nothing in the air of their actions or attitudes, or the style and cast of their limbs or features, that reminds us of their belonging to our own species', and called his style 'the language of the gods'.

Dividing the vast area with a painted architectural framework into a series of alternating large and small panels, which appear

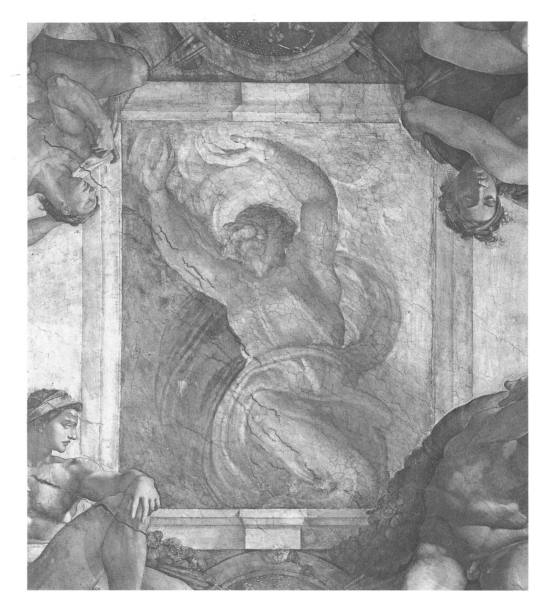

Plate 24
Let There be Light

open to the sky, Michelangelo worked his main theme – the Histories – along the central flattened strip. They tell the story of the Creation, the story of Adam and Eve, from the creation of Adam to the Expulsion from the Garden of Eden, and the story of Noah – the Flood, the Sacrifice and the Drunkenness.

Each of the smaller panels is surrounded by four nude youths – *The Ignudi* – and the whole concept is presented as far as possible in terms of the human body. There are twelve enthroned figures – the Hebrew Prophets, Isaiah, Jeremiah, Ezekiel and Daniel, Joel, Jonah and Zechariah; and the five pagan Sibyls – Libyan, Persian, Cumaean, Erythraean and Delphic.

In the four corner spandrels are shown the Salvations of Israel – David and Goliath, Judith and Holofernes, the Crucifixion of Haman and the story of the Brazen Serpent. The lunettes contain the ancestors of Christ and above them are smaller nude figures.

The Histories, though painted in reverse order, begin over the altar and work away from it in sequence. In the Sistine Chapel the altar, somewhat unusually, is at the west end.

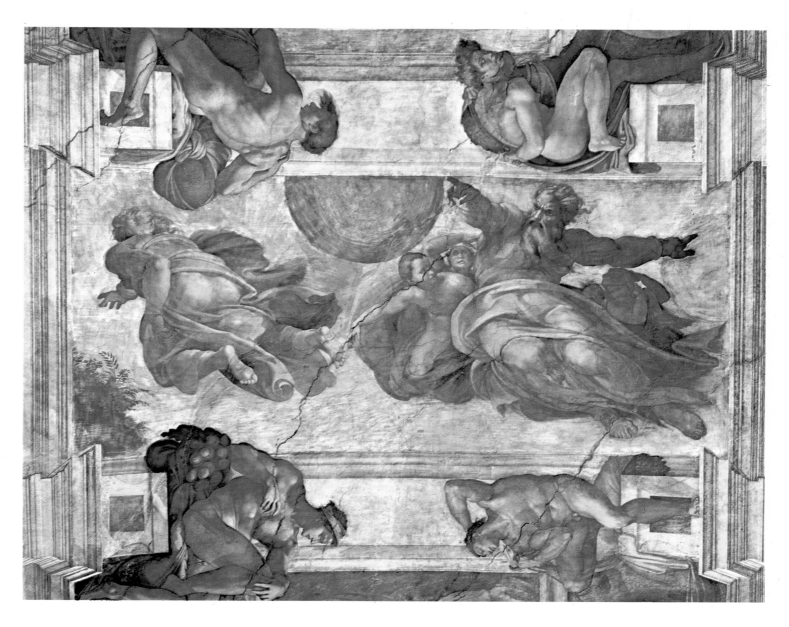

Plate 25
The Creation of the Sun and Moon

Let There be Light (plate 24) is the portrayal of the Creation itself and God is seen with his arms lifted high above his head, giving shape to the world. The movement is accentuated by the curling swirls of the drapery. The colour is pale and in many respects this is the most peaceful and least troubled of all *The Histories*, as though both creator and created are at one with each other and in complete control of the situation. Michelangelo is able to show the most dramatic of all happenings in an unaffected, perfectly natural, simple way.

The Creation of the Sun and Moon (plate 25), on the other hand, is all action and God seems in difficulty, even angry at his predicament. On the right, his massive figure, supported by angels, roars towards us, and all is noise and tension. On the left, he hurtles on into infinite space as though intent on his next task, the creation of the fruits of the earth. Full of dramatic gesture, arms spread wide, he orders the sun and moon to their allotted places.

Though the colour is again pale, there is much strong painting, with the deep folds of the drapery giving the sculptural depth and

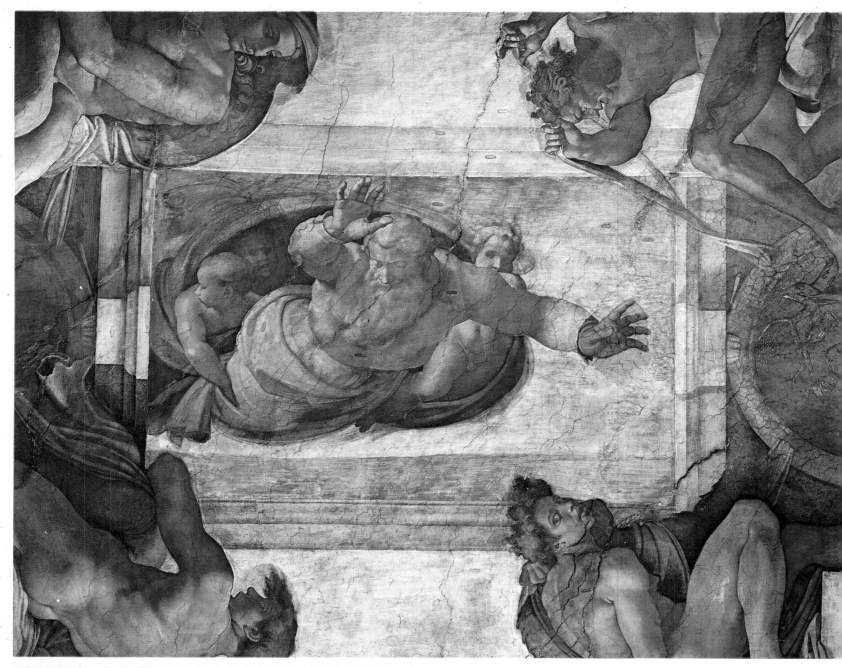

Plate 26
God Dividing the Waters from the Earth

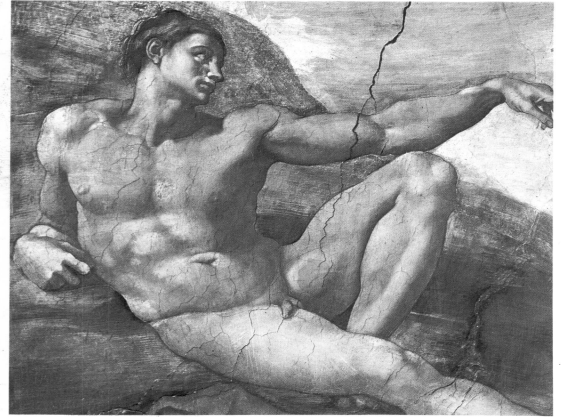

Plate 28
Adam
Detail from The Creation of Adam

36

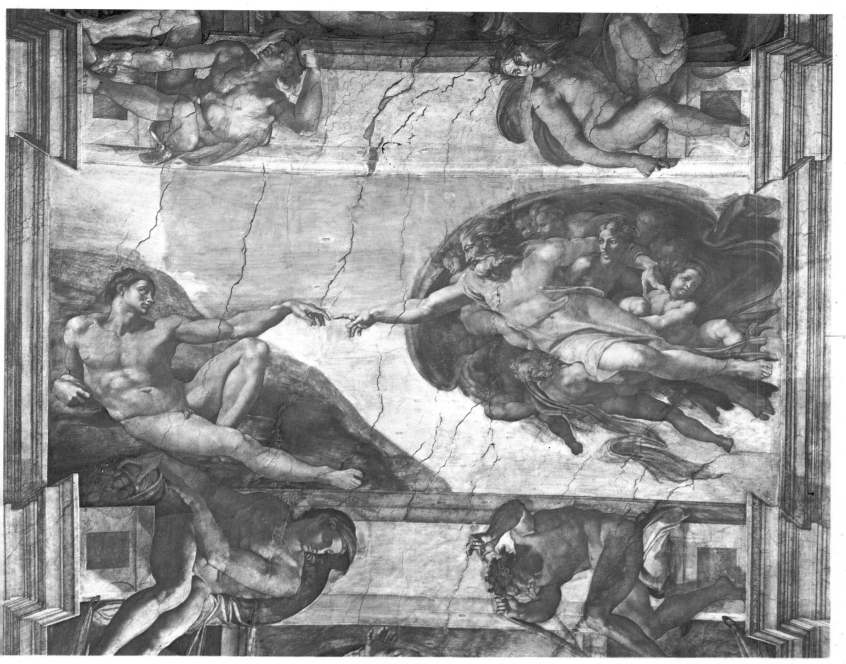

Plate 27
The Creation of Adam

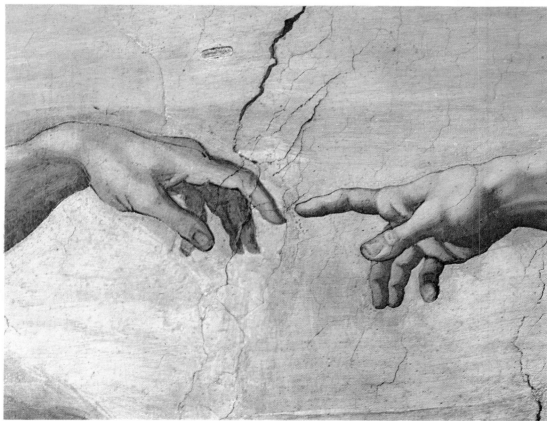

Plate 29
Hands
Detail from The Creation of Adam (see plate 27)

37

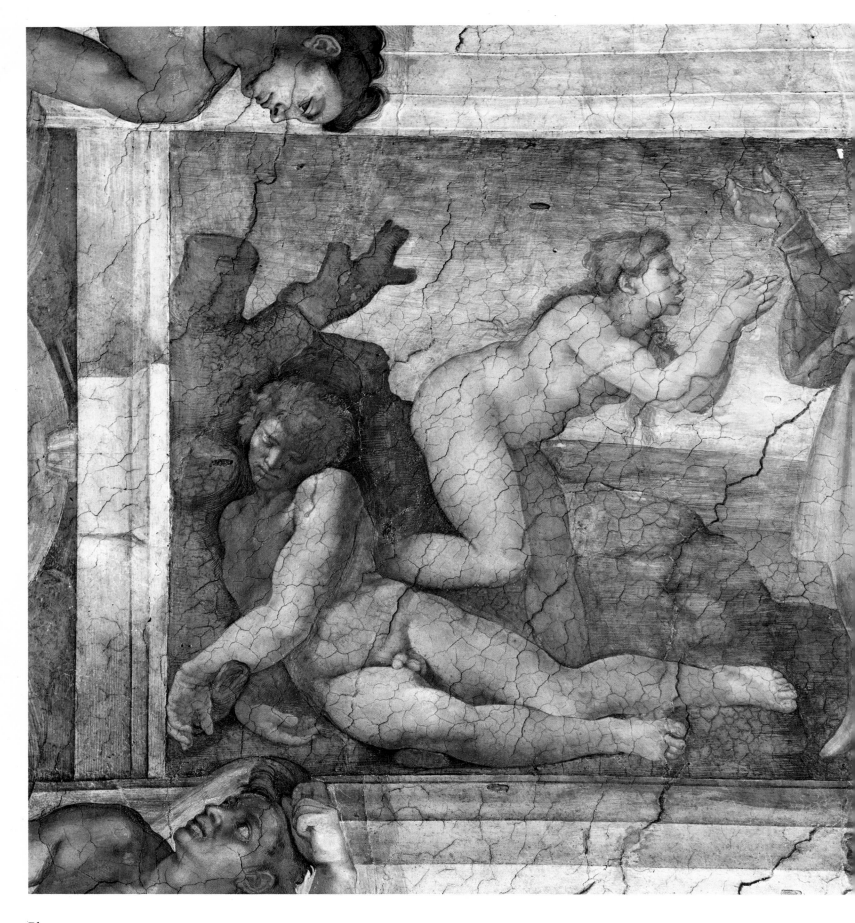

Plate 30
The Creation of Eve

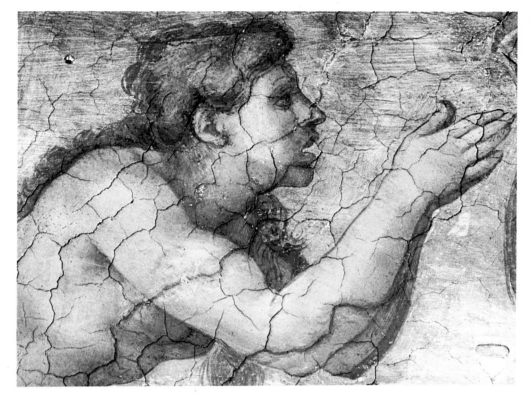

weight to the figures. The figure of God clearly foreshadows the *Moses* Michelangelo was to carve later, and there has been some suggestion that in these scenes of the Creation, Michelangelo also had Pope Julius in mind.

His treatment of God is consistent. He sees him throughout as an all-powerful figure, showing him in each case in a different mood rather than emphasising any specific characteristic. Michelangelo's conception of God is unswerving from the first appearance of the deity in the Sistine ceiling—the grey-bearded father-figure, both kind and terrifying, capable of the most amazing feats, but always with us. He floats gently towards us as he divides the waters from the earth (plate 26) almost nonchalantly, his outstretched arms merely easing the elements apart. He knows exactly what he is doing, and there is no need for violence. Even the supporting angels seem distracted and all are held quietly in a great oval of enfolding drapery.

This painting completes the first group of three *Histories*: the world is now ready for Man.

The Creation of Adam (plate 27)

To Michelangelo Adam is not only the first *man* but the heroic image of God in human form. God made him—nude and in his own image. He lies at once beautifully elegant and athletically powerful, slowly stirring into life, arm reaching out towards his creator.

Vasari says: 'Adam, a figure whose beauty, pose, and contours are such that it seems to have been fashioned that very moment by the first and supreme creator rather than by the drawing and brush

of a mortal man'. Adam is Michelangelo's most obvious
concession to the accepted notion of total beauty (plate 28).

God, borne by a group of nude angels and with the image of
Eve tucked under his left arm, is all-powerful. His muscular body
drifts easily within the dark swirl of his cloak and he leans
deliberately to where Adam reaches for him. Their fingers almost
touch in what is one of the most evocative pieces of painting of all
time (plate 29). The minute space between their fingers is more
suggestive of the first spark of life that jumps from one to the other
than any comparable image. Michelangelo has suggested the act,
rather than described it, and this piece of understatement is typical
of the reverence and awe in which he held his subject.

Perhaps he was 'no painter', but in this one scene he is able to
capture all the psychological awareness between the two figures
with all the conviction and assurance he brought to his work with
hammer and chisel. In this sense the sculptural quality is an
advantage; the Creator and his hero need to be statuesque to draw
attention to the unreality of the event.

There needs to be an air of the supernatural here, and by stressing
the monumentality of the figures, Michelangelo achieves just the
right effect.

The Creation of Eve (plate 30)
Eve rises from Adam's side as he lies asleep, God stands squeezed
into the right-hand side of the panel, and there is the suggestion of
a barren landscape. It has much of the quality of a carved relief and
is the least successful of all *The Histories*.

There is so little space in the composition that the well-formed
figure of the naked Eve dominates, making for a certain lack of
narrative coherency. Seen in detail, the painting is impressive, from
the power of the sturdy body to the delicacy of Eve's half-open
expectant lips as she rises to receive God's blessing.

One of the problems of the Sistine ceiling is that it was intended
to be seen as a complete unit and not as a series of tableaux, but
we have become so familiar with the details of it through constant
reproduction, that it is easy to lose sight of the initial concept and
to concentrate on small details like the painting of the head of Eve
(plate 31), which *in situ* is high above our heads.

The Fall and Expulsion of Adam and Eve (plate 32)
Here Michelangelo was compelled to telescope two instalments
into the one painting and what we see is a chain of events, the
cause and the effect. Symmetrically balanced–almost Renaissance
in design–on the left we see *The Temptation,* and on the right *The
Expulsion*. The whole composition is divided in the centre by the
tree and the tight corkscrew of the serpent with its upper,

Plate 32
The Fall of Man
(Combining **The Temptation** and
The Expulsion)

40

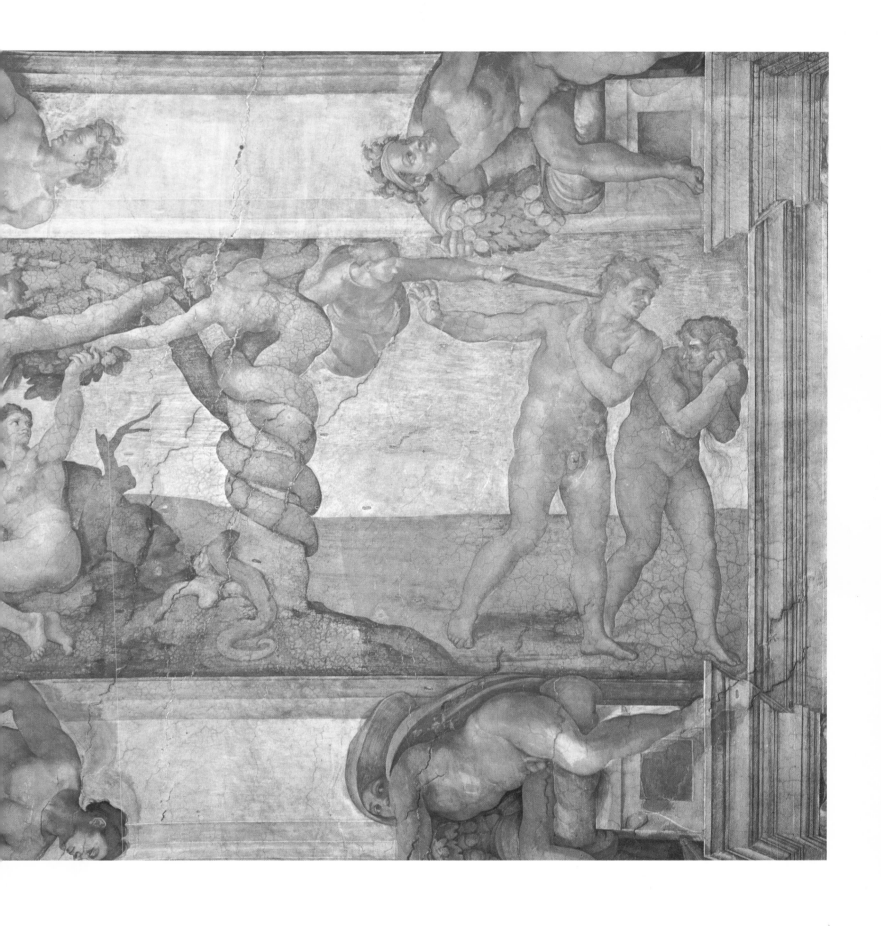

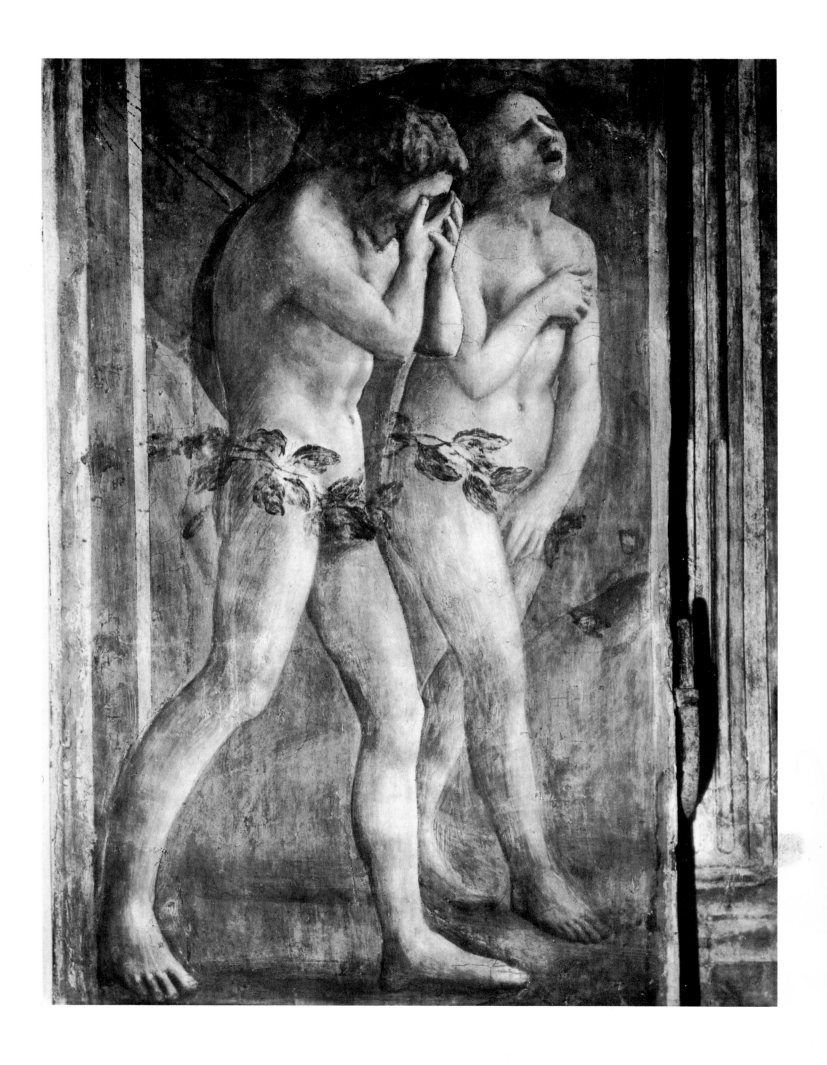

deliberately described, female form. He was forced to introduce a landscape, but he did as little as possible to define any specific vegetation. Walter Pater describes it as 'only blank ranges of rock', and it suggests more Michelangelo's *Paradise* of Carrara than the sumptuous *Garden of Eden*. He treats it purely as stage-setting and it plays a minor part in his story.

Masaccio seems to have been his inspiration (plate 33) and the two figures on the right are very reminiscent of those in the Brancacci Chapel, but the subject is one of the first subjects of Christian art to inspire the use of expressive nudes.

All four figures are strong and powerful and there is a total lack of sensuality. In his carving Michelangelo was capable of extreme seductiveness, but in this case – when he had every excuse for it – he seems unable to stretch himself beyond mere physical description. It is possible that the subject was really outside his understanding and there is no doubt the medium has a certain dryness. As a painter, however, his range did not include the more subtle and emotional qualities of tactile description. Eve is tempted, so too is Adam, and the serpent girates evilly – there is a certain sensuality here – but unless we know the story, Michelangelo is of little help. Throughout his career he cared little for narrative illustration. His method is very much in the Florentine linear tradition, relying heavily on the drawn outline, and it is this that holds the composition together. His mastery of the nude stands him in good stead: all the figures have their feet firmly on the ground, remaining very much of our world. We know it is our own sin to which he is drawing attention.

The Flood (plate 34)

In many ways the most descriptive of all *The Histories,* it clearly shows the rising flood and the ensuing panic. Small incidents are described in naturalistic detail, and clearly Michelangelo is in sympathy with his subject. Perhaps, working in isolation and having to cope with immense physical difficulties, he was able to identify with their problems – the mother's fear for her baby, an older child clinging in terror to her leg, the man with his wife on his back – which are all seen with the clear simplicity almost of Giotto. We see his sensitive handling of death; the only actual corpse in the painting is held lovingly in the arms of an older man, who seems to care more for it than for his own safety.

Michelangelo combines these poignant details into a total evocation of terror. His innate compassion for humanity constantly lets us know that he is well aware of the struggle for existence.

Noah himself appeals for help from the safety of an amusingly

Plate 33
The Expulsion of Adam and Eve from Paradise
Masaccio
1427
Fresco
9 ft $9\frac{7}{8}$ in × 3 ft $\frac{1}{2}$ in
Brancacci Chapel, Sta. Maria del Carmine, Florence

43

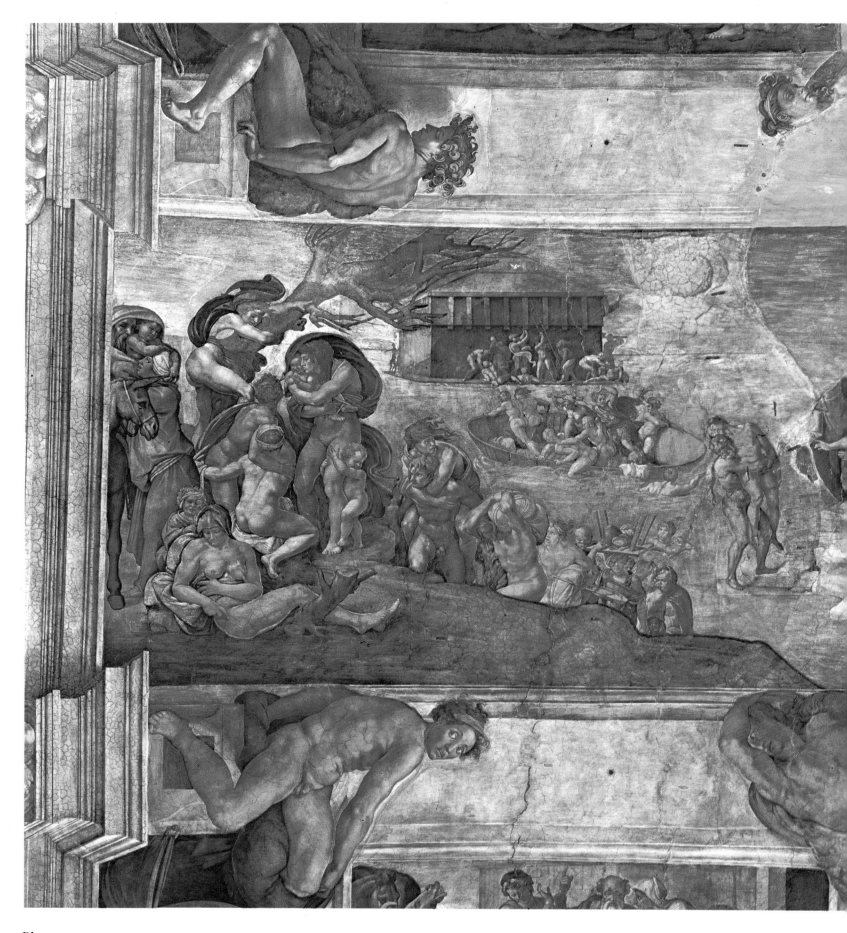

Plate 34
The Flood

conceived ark, the solidity and security of which is accentuated by an over-crowded – obviously fated – boat, that tries vainly to reach it. At times Michelangelo shows a touchingly naïve quality, which rather gives the lie to the suggestion that all his thoughts were concerned with despair and melancholy. Though stylistically so much more sophisticated than the earlier Florentines, he never conveys a feeling of smugness or self-satisfaction and is always trying something new. In the case of *The Flood*, he makes a brave attempt at something which, in terms of actual painting, must have stretched his abilities to the limit.

After this, *Noah's Sacrifice* is something of an anticlimax. Safely back to earth after forty days and forty nights, there is none of the feeling of relief, except in the rather shallow, sculptural, spatially confused treatment of the scene. The figures are painted against a background of deliberately defined perspective, which works in linear terms, but there is no air and the figures seem cramped into too small a space. It is difficult to see exactly what he had in mind, there is much posturing and the characters seem over-defined, but more disturbing is the weight of the composition, seeming, as it does, to hang rather precariously above our heads. Of all *The Histories* it comes closest to a painting, and consequently is by far the least happy in the overall scene.

The Ignudi

These elegant, muscular young men sit naked, compressed into their architectural framework, one at each corner of the five *Histories*. There are therefore twenty of them. Twisting and turning with graceful, languid movements, it is with them that Michelangelo feels most at home. They are the peak of his achievement as a painter, and with them he is able to combine his sculptural feeling for well-defined form with his linear precision as a draughtsman, and the result is that he works freely for the first time as a complete artist, without worrying whether he is sculptor or painter, as Vasari says:

'Painting seems to me to be held good the more it approaches relief, and relief to be held bad the more it approaches painting; and therefore I used to think that sculpture was the lantern of painting and that between them one and the other was that difference which there is between the sun and the moon'.

Michelangelo deliberately sets out to celebrate the beauty of naked youth – his life-long obsession – obviously delighting in the bodies of these young men, enjoying their physicality, enjoying the smoothness of their skin. They are surely the most perfect of all his painted figures. Conscious of their attraction, they sit in an

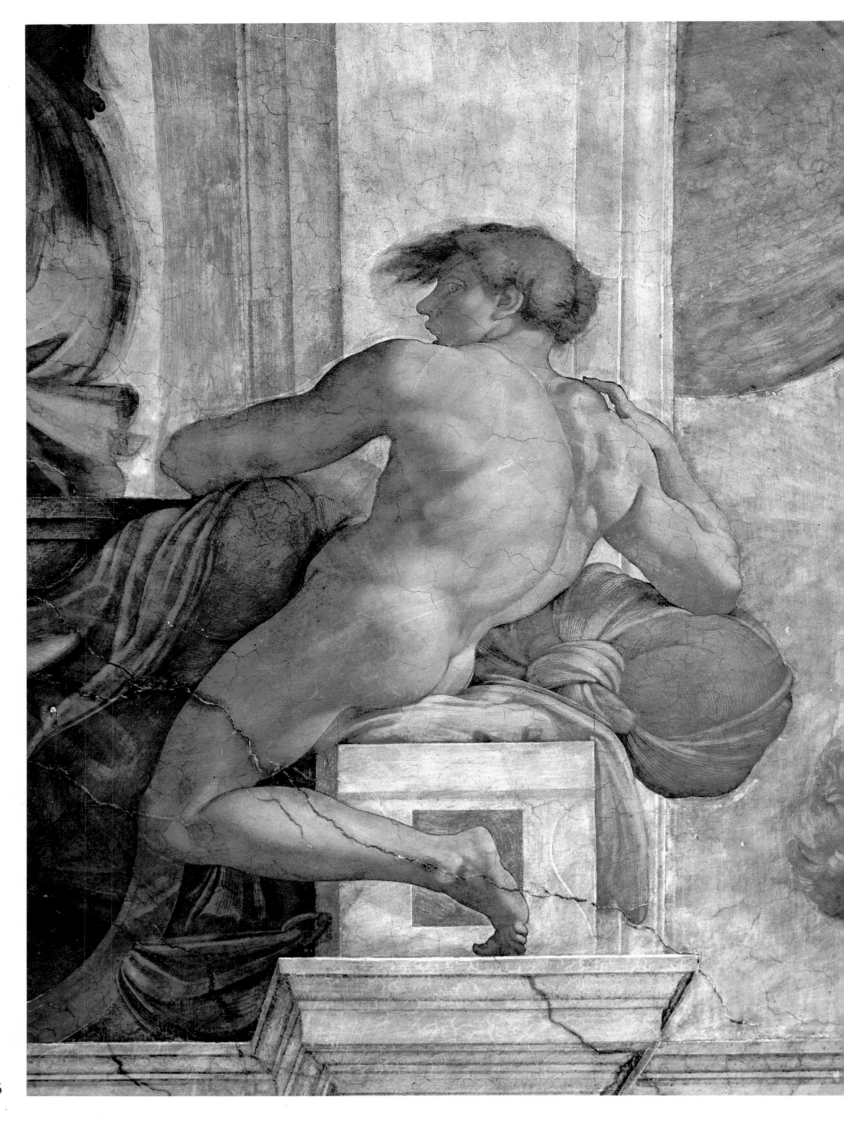

Plate 35
An Ignudo
Detail above and to the right of
The Persian Sibyl

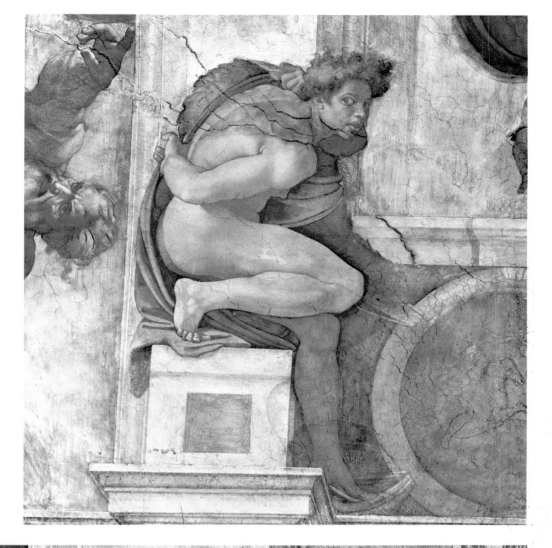

Plate 36
An Ignudo
Detail above and to the left of
The Prophet Daniel

Plate 37
An Ignudo
Detail above and to the right of
The Delphic Sibyl

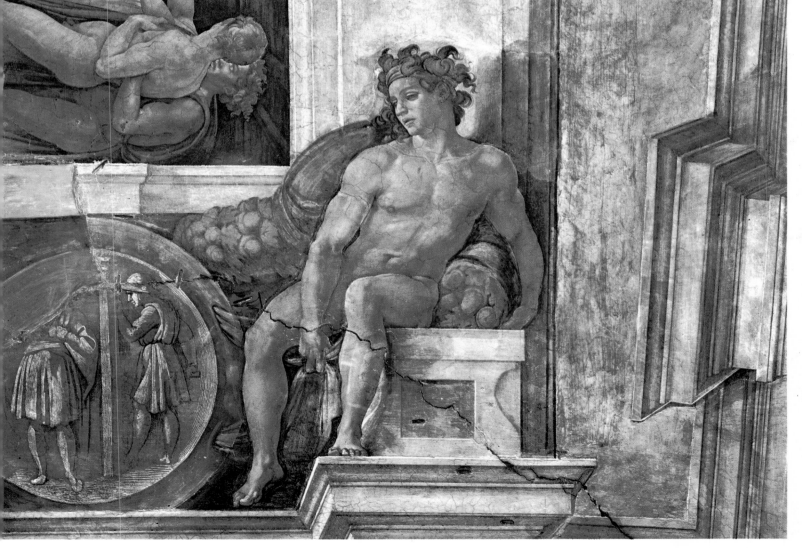

47

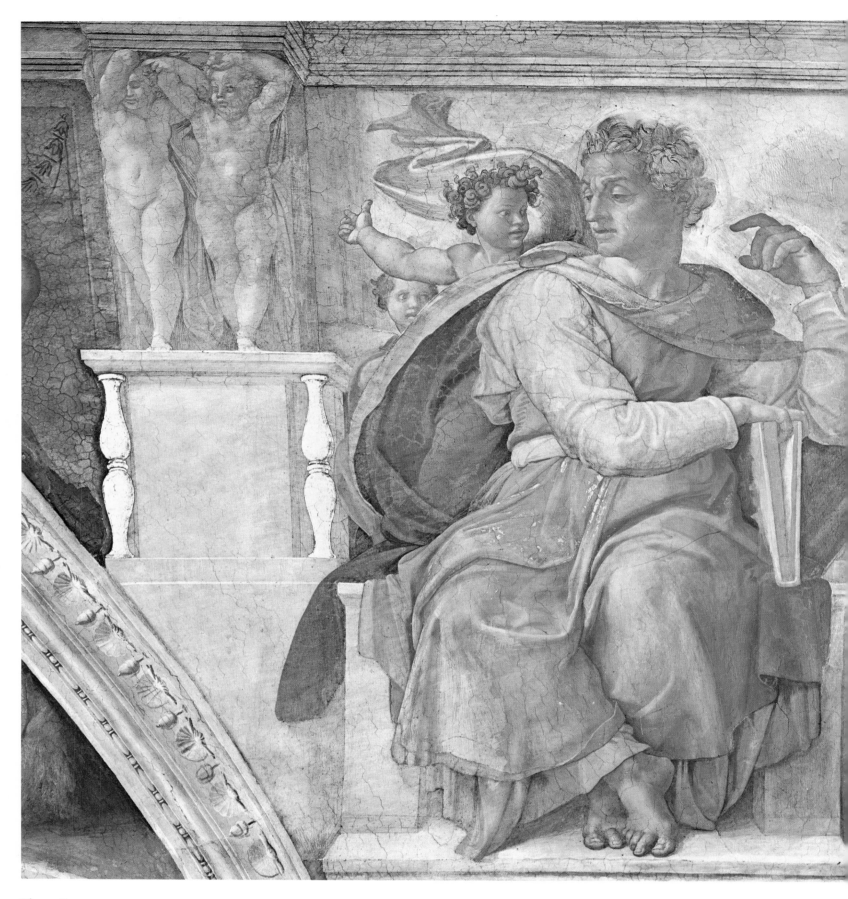

Plate 38
The Prophet Isaiah

endless variety of poses, but what we see is not a series of individual figures–they are one and the same 'man'. Michelangelo strives for an overall effect, wanting us to realise that what he feels is too important to have but one tangible form, that it calls for many interpretations and that we must understand that life is not simple. When we look at these ambiguous figures and talk about the 'bi-sexual congregation of the Sistine vault', we know that throughout his career Michelangelo hints at his confusion and here he is given the heaven-sent opportunity to directly and unashamedly profess his admiration for the naked young male body.

There is nothing abstract about *The Hebrew Prophets* who foretold the coming of Christ; they exist as people and each has a definite personality. The art of the High Renaissance was based on objectivity. Michelangelo breaks right away from this, and gives us in these figures not only their outward appearance, but the mood of their innermost thoughts, an essentially subjective interpretation.

We see *Isaiah* (plate 38), the articulate intellectual, sitting with comparative ease comfortably within his throne, which fits clearly into its architectural setting. Sophisticated and somewhat idealistic – almost starry-eyed–his hands are pressed between the leaves of his half-open book. 'Behold, a virgin shall conceive, and bear a son, and shall call his name Immanuel'. *Isaiah* is elegant and self-assured. Everything about him oozes conviction.

Ezekiel (plate 39), perhaps caught in the midst of a strange vision, springs up and bursts out of his imprisoning framework, his intense face disturbed by some nonsensical thought, but desperately needing to be understood. *Ezekiel*, the wild visionary, the eccentric, his cloak caught in tight spiral coils, his feet aggressively astride, clutches his scroll obsessively in his left hand. This is Michelangelo at his best, the brushwork surging across to show the vigour of the prophet as he leaps suddenly to his feet.

We see the lamenting, anxious *Jeremiah* (plate 40), head in hand, deep in thought, melancholy and preoccupied with the disasters to come, his hand pressed deeply into his jaw. 'The Lord hath afflicted me with sorrow in the day of his fierce anger'–he bemoans his plight. His feet are crossed in trepidation, as though even to move might well bring retribution down on his head.

So too with *Daniel* (plate 41), the young prince of Israel, tense, his neck taut, his arm barely supporting his book–even with the help of a small nude *putto*: all this helps to convey the sense of spiritual strife. The twisting of the figure in its unhappy space and the strong feeling of inconclusive depth adds to the figure's latent

Plate 39
The Prophet Ezekiel

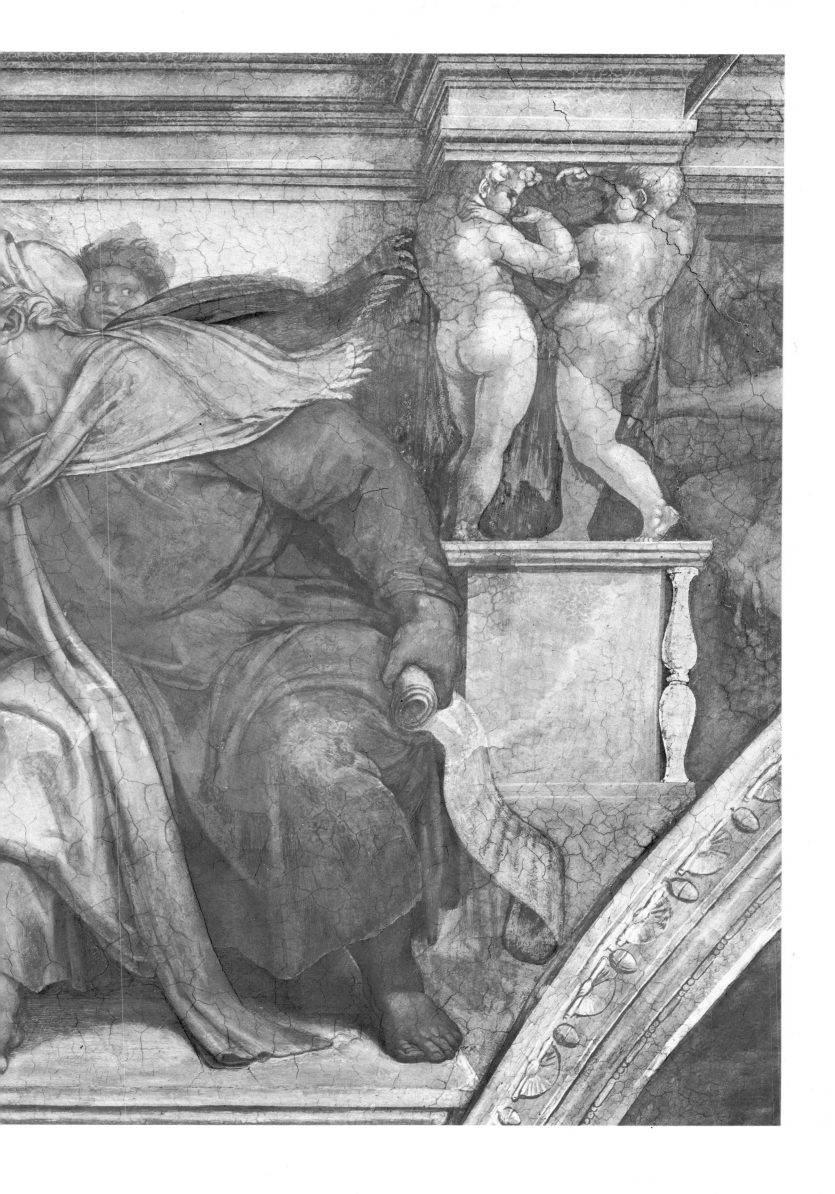

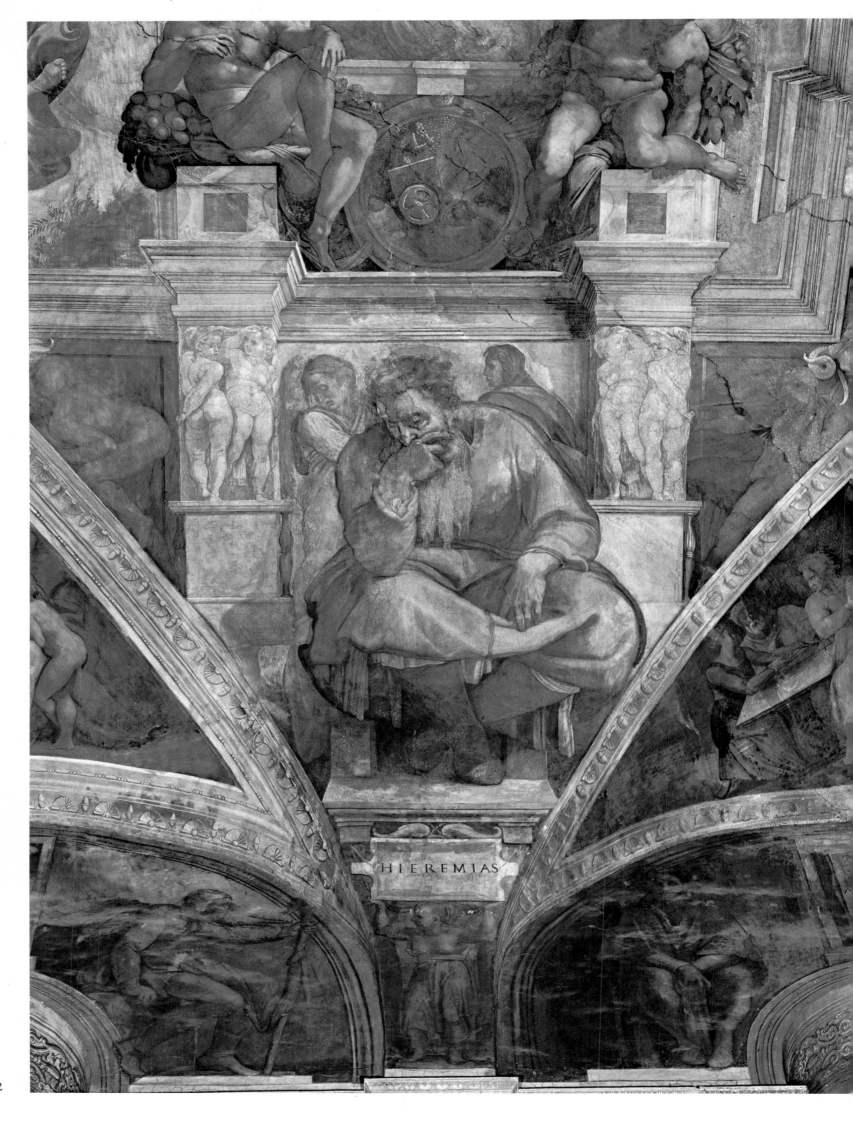

HIEREMIAS

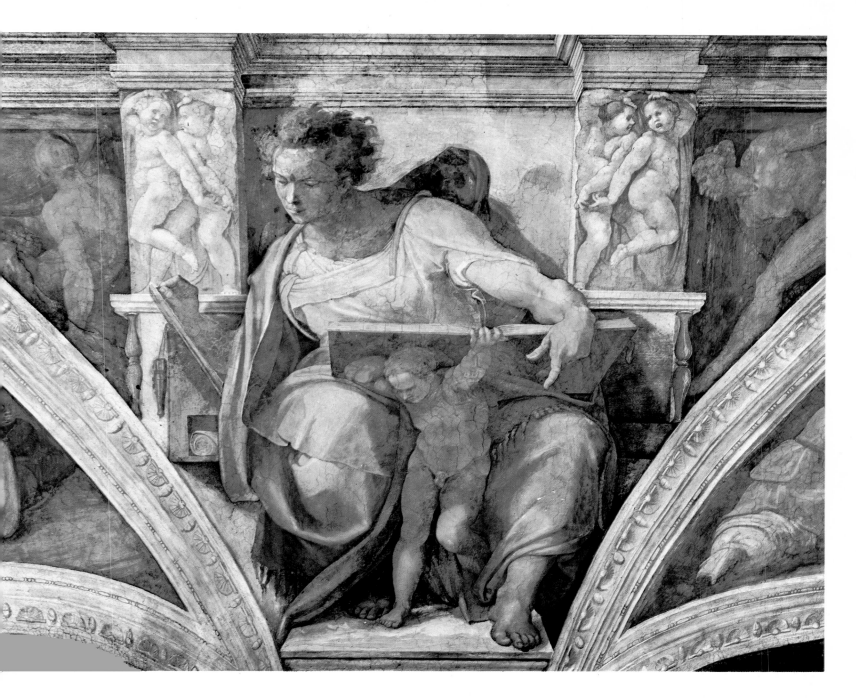

The Book of Jonah, c.4, v.9.

obstinacy, and we can well understand the lion's difficulty with him.

The minor prophets, *Joel* (plate 42), *Jonah* (plate 43) and *Zechariah* (plate 44) are treated with equal care, and indeed, *Jonah* is in many ways the most commanding figure of them all, situated as he is above the altar. 'I do well to be angry, even unto death'[1] – one feels that Michelangelo must have felt great sympathy for *Jonah*, who sits almost nude, leaning on his right elbow and reaching far back into his niche. Like *Daniel* he has the strength of the survivor, is too tough to die, and is immediately sympathetic. Wherever one stands it is *Jonah* who catches the eye; this is '*Il Terribile*' at work, deliberately showing the anger of *Jonah* above the altar of the Sistine Chapel, of all places.

Joel is mild in comparison, absorbed in his scroll, very much the thinking man. There is nothing to disturb us here.

Even old *Zechariah* is shown in true character, turning away, searching for something particular in his thick book. Flat and formless, his bald head and long white beard contrast with the features of the younger prophets. All are definite characters and Michelangelo has been at pains to make them so.

The pagan *Sibyls*, from Classical mythology, alternate with the prophets. They are shown in their equally important role as prophetesses.

The Libyan Sibyl (plate 45) turns away from us and appears to be closing her book. She is poised–posed almost–halfway through a deliberate action. There is a particularly fine drawing for this figure (plate 46), where Michelangelo has worked out in great detail the subtle forms–in particular of the turning back. One cannot help feeling that, despite the hint of the later 'Mannerism' in this figure, in the end the drawing dictated the form, rather than vice versa.

The study shows Michelangelo at his very best, with all the anatomical articulation and spatial understanding that make him such a superb descriptive draughtsman. No one handles form more convincingly. Not even Leonardo can equal his understanding of bodily movement; no one understands better the subtle effects of light and shade.

The Persian Sibyl (plate 47), older and more delicate, peering into her little book, obviously looking for some small detail, is less immediately impressive than the superbly massive *Cumaean Sibyl* (plate 48), one of the most monumental of all the figures in the ceiling and very much foreshadowing the painting in *The Last Judgement*. Exaggeratedly asexual, with the huge limbs and shoulders of a powerful man, but still obviously female, she seems too large for her throne, which one fears is incapable of supporting her colossal weight. Almost cumbersome, she too hangs precariously above us.

Not so *The Erythraean Sibyl* (plate 49), who foretold the Day of Judgement, and is shown off-handedly turning the pages of her book. Formally she is the least disturbing of all *The Sibyls,* but in no way compares with the figure of *The Delphic Sibyl* (plate 50), which is one of the most delicate pieces of painting in the whole scheme and which shows Michelangelo in full command. She sits gazing abstractedly in front of her, with the suggestion of hidden understanding, as though she is aware of something which is too important to tell us without thinking very carefully about it first (plate 51). There is the suggestion of doubt in her mind, and all the subtlety of her thought is shown and we readily accept her reticence.

Plate 42
The Prophet Joel

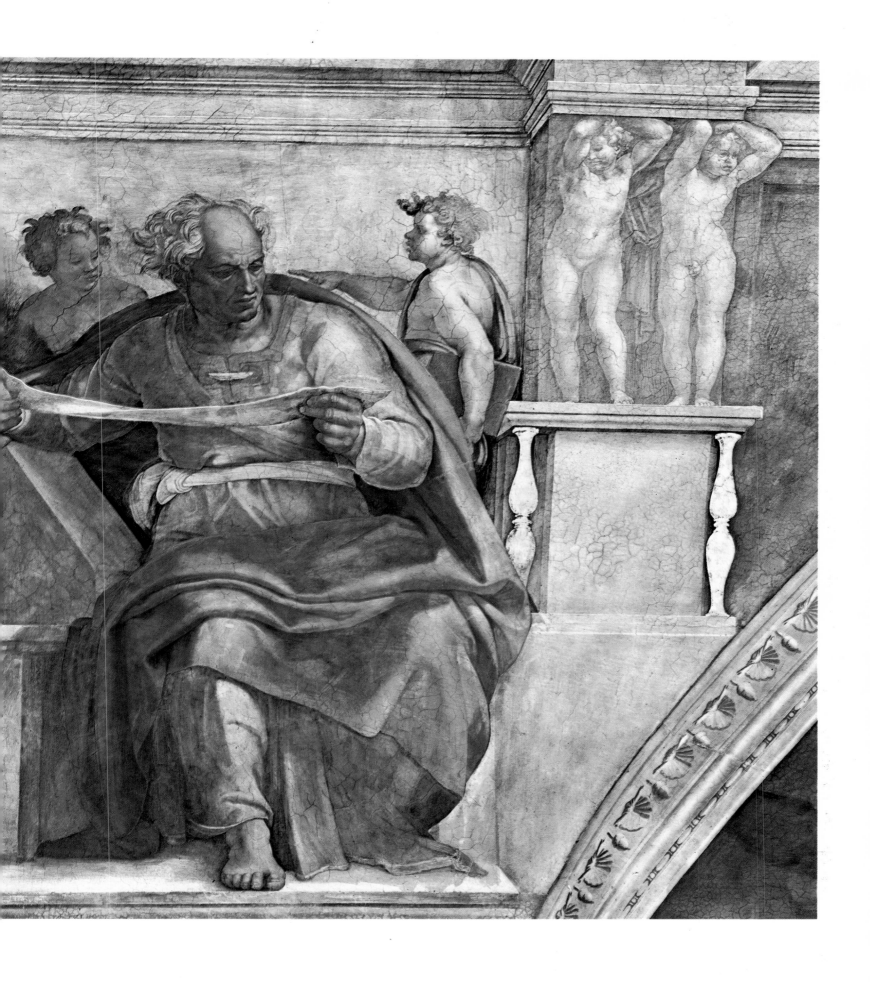

55

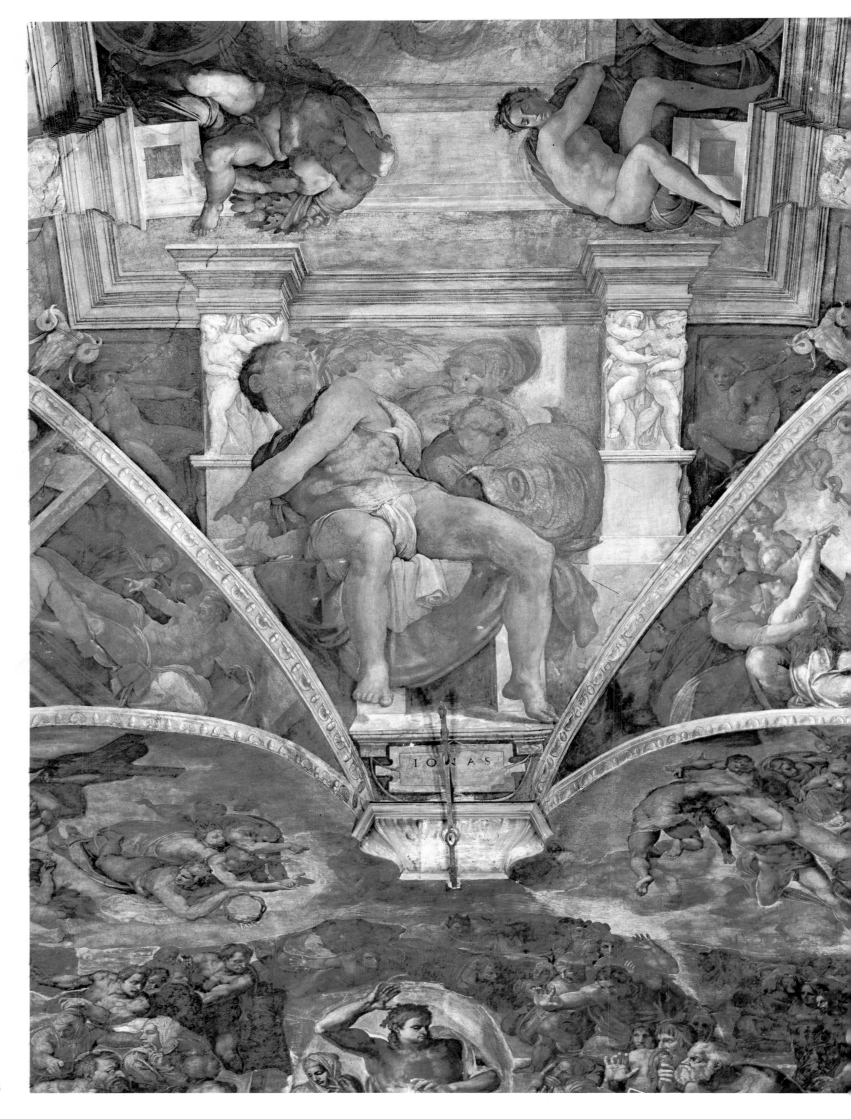

Plate 43
The Prophet Jonah

The Salvations of Israel—David and Goliath, Judith and Holofernes, The Crucifixion of Haman and *The Brazen Serpent*—were painted at the same time as *The Histories,* and fill the triangular spandrels in the four corners. They show the victories of youth, of weakness over strength, of grace over violence, and their subject matter calls for dramatic treatment. Michelangelo moves closer to illustration here than in any other part of the ceiling, showing David in the act of slaying Goliath, the death throes of Holofernes, the last struggles of Haman, while in *The Brazen Serpent* he gives full vent to his interest in tormented poses and foreshortened figures in a composition which has very little of the order of the High Renaissance, and looks forward to some of the more bizarre offerings of Mannerism. There is something of Giulio Romano about it.

The Ancestors of Christ are treated very much as human beings, in simple family settings—'The poor and needy are the true family of Christ', said Savonarola, and Vasari saw them as 'a mass of remarkable new fancies', rightly suggesting that Michelangelo had treated the biblical themes in a freely descriptive way.

He finished work on the ceiling at the end of October 1512. It had taken him nearly four years and at once it was acclaimed as a supreme work of art.

'I have finished painting the chapel, and the Pope is very pleased with it'. At thirty-seven Michelangelo was regarded as the greatest living artist—not only a great sculptor, but now also a great painter, and the phrase '*Il Divino*' was used for the first time. As Goethe rightly said: 'No one who has not seen the Sistine Chapel can have a clear idea of what a human being can achieve'.

Maturity

The ceiling completed, Michelangelo now felt that he had the time to concentrate fully on the tomb, but on 21 February 1513 Julius died, and again he was forced to think of other things.

His childhood friend, Cardinal Giovanni de' Medici, younger son of Lorenzo the Magnificent, was elected Pope Leo X and immediately commissioned him to complete the façade of the Medici family church in Florence – Brunelleschi's San Lorenzo (plate 52).

In his designs for the façade, which he conceived as an elaborate framework for over life-size sculpture, he tried to break away from the architectural style of the Renaissance. The designs, however, still retain a distinctly Florentine flavour.

Unfortunately, this proved to be another project doomed to failure. After wasting precious time in travelling to Carrara, coping with difficult labour problems and being harassed on all sides ('I have undertaken to raise the dead in trying to domesticate these mountains and bring art to this village'), quite suddenly and to his 'great humiliation' the scheme was abandoned.

Even without a façade, San Lorenzo stands as a suitable monument to Michelangelo. The church of his greatest patrons – the Medici – where he did some of his finest work, symbolically remains faceless and unfinished.

Meanwhile, Julius's heirs had new plans for the tomb. It was now to be a wall-monument, still on an ambitious scale and to be completed in seven years. It too was doomed to failure. Michelangelo's reaction was: 'I do not want to go on living under this burden – I have wasted all my youth chained to this tomb'.

He carved three figures for it, and only one – *Moses* – was used in the final version where, more or less by chance, it became the central figure. The other two are now in the Louvre and were never used. They were *The Struggling Captive* and *The Dying Captive* and were intended as allegories of the arts.

The Struggling Captive (plate 53) is unfinished and stands with his right foot on a rock. His muscles bulge with his efforts to free himself, both from the thong that ties his hands behind his back,

Plate 44
The Prophet Zecheriah

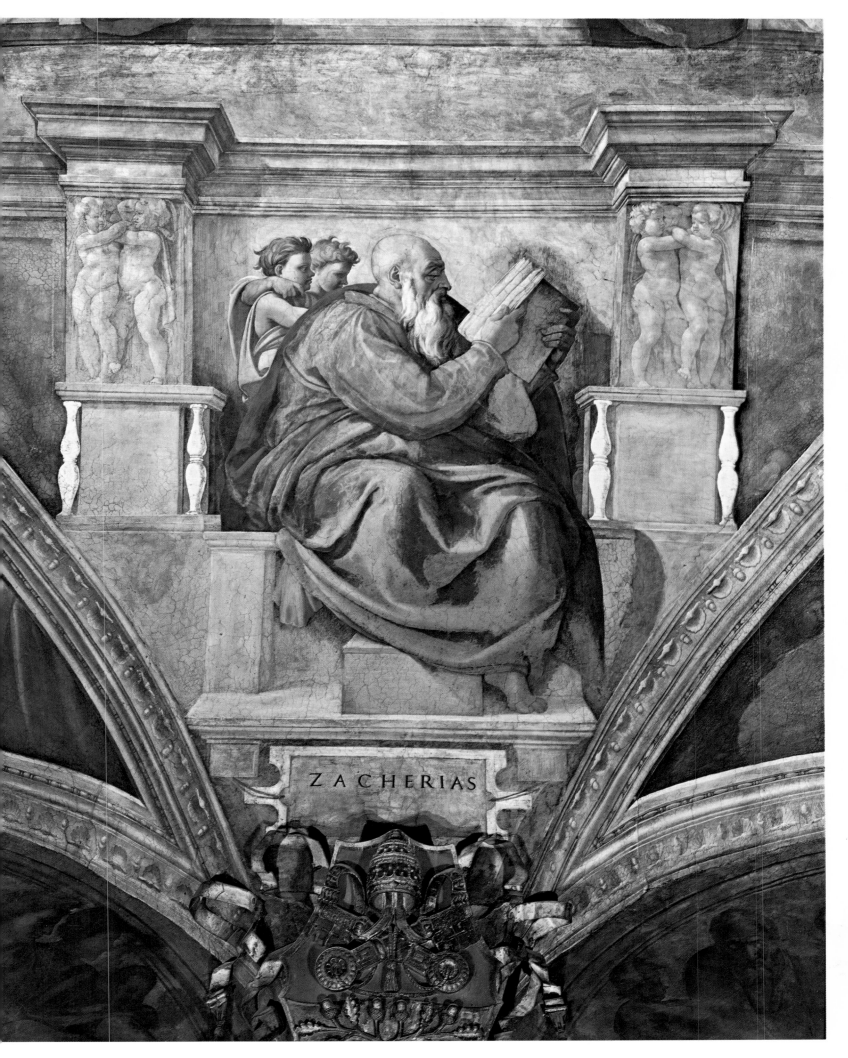

ZACHERIAS

59

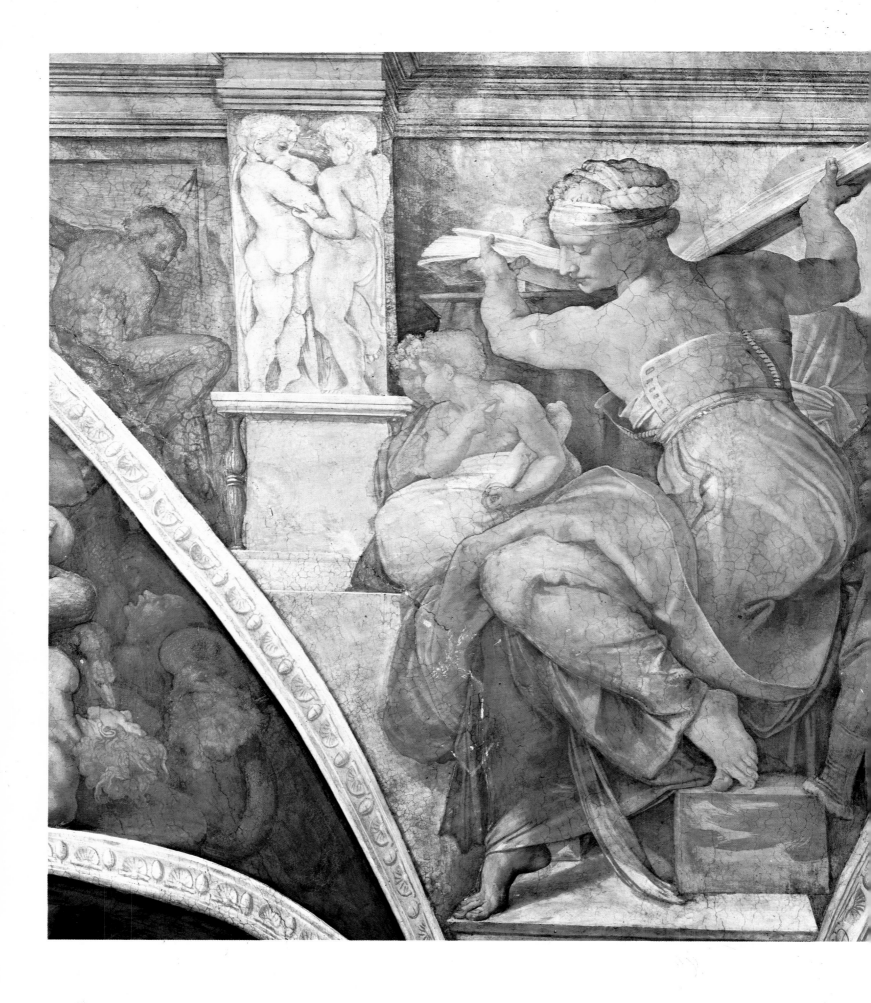

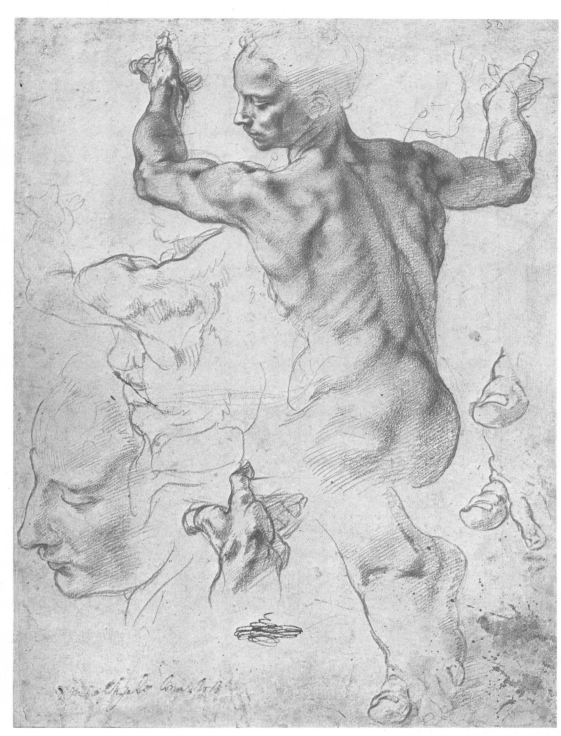

Plate 45
The Libyan Sibyl

Plate 46
Studies for The Libyan Sibyl
Red chalk
$11\frac{3}{8} \times 8\frac{1}{2}$ in (28.8 × 19 cm)
The Metropolitan Museum of Art,
New York
(Purchase 1924, Joseph Pulitzer Bequest)

and the frustration he feels at being held captive. He needs to be seen from the left and his head turns towards us in agony. Obviously he will not break the thongs and he struggles in vain.

The Dying Captive (plate 54) is deceptively effortless and we sense that he has come to terms with his plight. He is about to collapse, but whether in death or sleep is not made clear. Exhausted, he leans elegantly backwards, his eyes closed, his right arm limp across his chest, his left hand supporting his head. There is something of the earlier *Bacchus* about him; he is almost too beautiful, and we sense that Michelangelo is again relishing the chance to carve his ideal.

The two *Captives* are both symbol and flesh and blood, very much Michelangelo, and not at all suitable for *The Tomb of Julius.*

Moses (plate 55)

Vasari wrote of *Moses*: 'There was no other work that could be seen whether ancient or modern, that could rival it'.

This massively impressive figure has all the qualities of a great painting and is very much related to the *Prophets* in the Sistine Ceiling. It is almost as though the chisel has become a paintbrush creating great rolls of flowing hair in the long beard, which falls across the body and reaches down to the waist. The body is strongly suggested through the lightly draped tunic; the massive knee thrusts towards us. Intended to be seen from some 12 or 13 feet below, the figure looms over us, and of all Michelangelo's sculptures calls out for an audience.

Stendhal said of it: 'Those who have not seen this statue, cannot realise the full power of sculpture'. And it is a supremely confident piece of work. Nowhere is there hesitation, all is totally under control; we sense that the sculptor put a lot of himself into it, that perhaps there is more to it than immediately meets the eye.

Though there is no doubt that it is Moses – we can see the all-important tablets under his right arm – the suggestion that it might in fact be Julius or an amalgam of Julius and the sculptor himself, has a certain appeal.

These were far from restful times for Michelangelo and soon he was reminded of his obligation to finish the statue of *The Risen Christ* made for the church of Santa Maria sopra Minerva, in Rome. Eventually completed by his assistant Pietro Urbino, and very much a 'mutilated masterpiece', it is hard to imagine it having any connection with the carver of *Moses*.

In many ways the least successful of all Michelangelo's work, even in concept, it has none of the latent abstract qualities that one associates with him. Its forced pose and insipid detailing show little of either his strength or sensitivity.

Plate 47
The Persian Sibyl

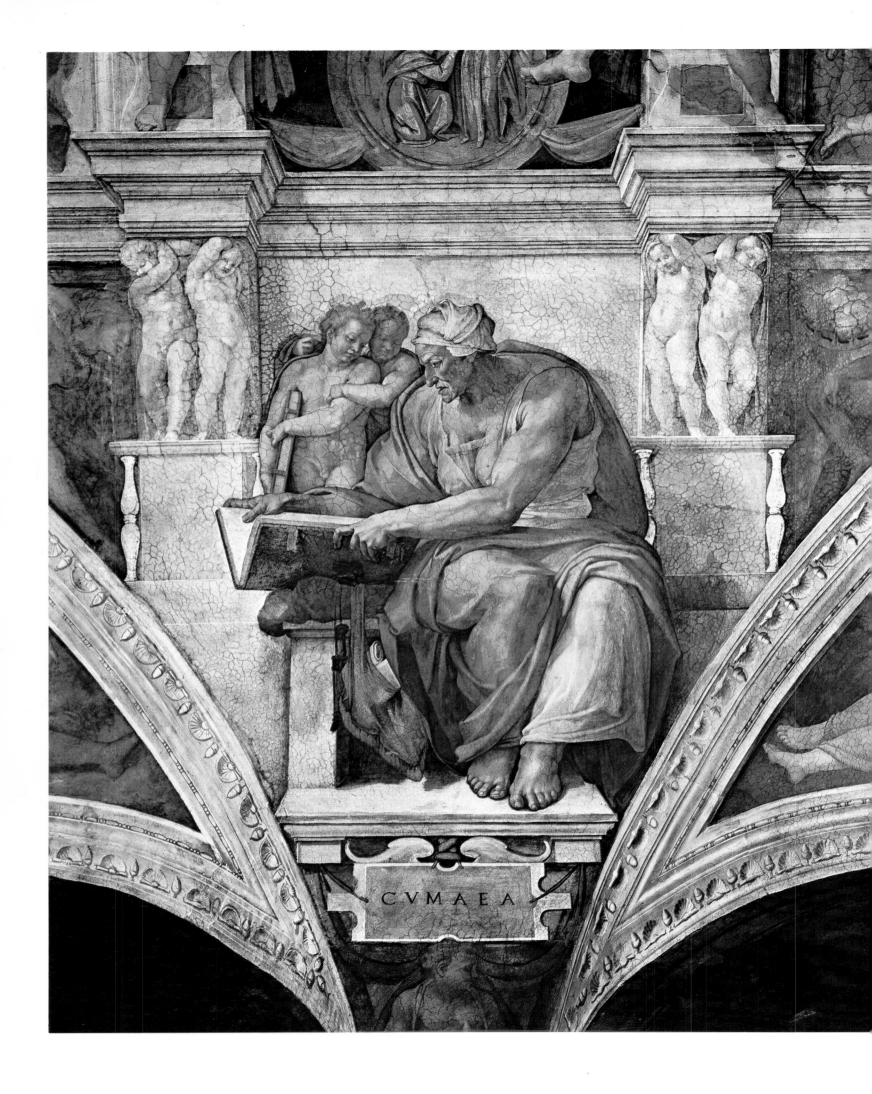

CVMAEA

64

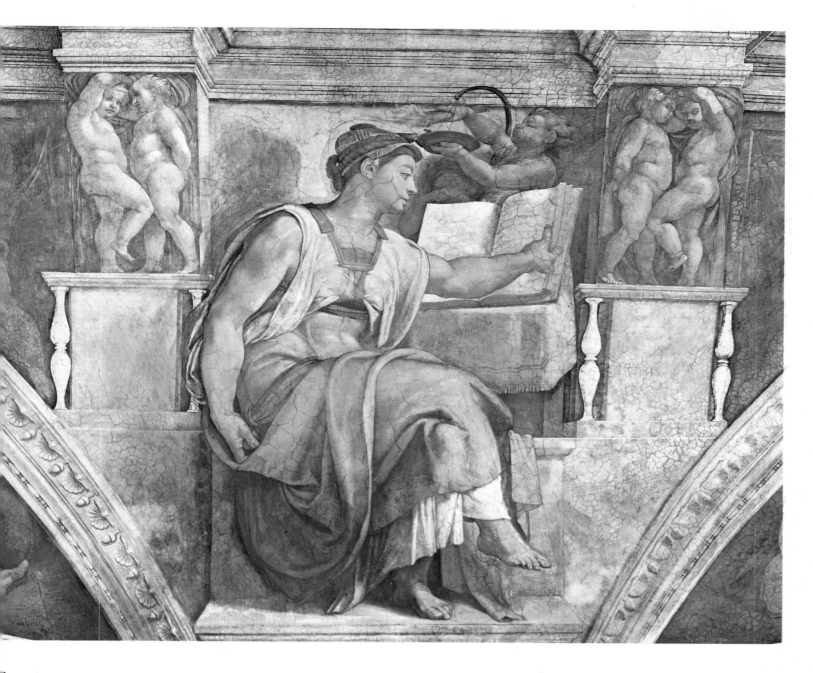

In 1520, however, Michelangelo accepted the commission to build a funerary chapel for the Medici family in San Lorenzo and this now became his main preoccupation.

The Medici Chapel (plate 56)

Commissioned by Cardinal Giulio de' Medici, later Pope Clement VII, and intended as a mausoleum for several of the Medici family, the original over-ambitious scheme was finally reduced to the two tombs of Lorenzo de' Medici, Duke of Urbino, and Giuliano de' Medici, Duke of Nemours, respectively son and grandson of Lorenzo the Magnificent. To this chapel, in San Lorenzo, Michelangelo devoted fifteen years of his life.

The work was constantly interrupted by the disastrous political events of the time—during the upheavals that followed the Sack of Rome he was in charge of the fortifications—but he stuck to his task until finally, in 1534, he left Florence for good.

Architecturally, the chapel is of less interest than the Laurentian

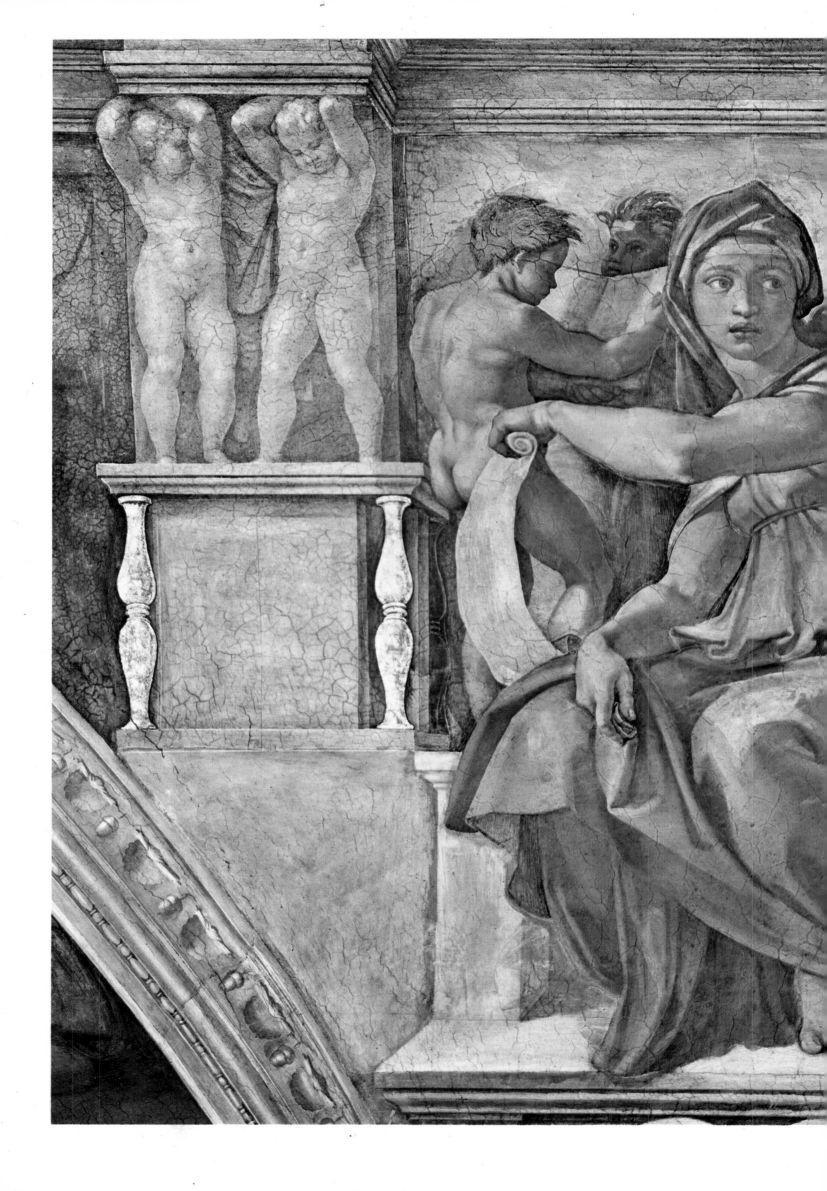

Plate 50
The Delphic Sibyl
Detail below and to the right of the
Drunkenness of Noah

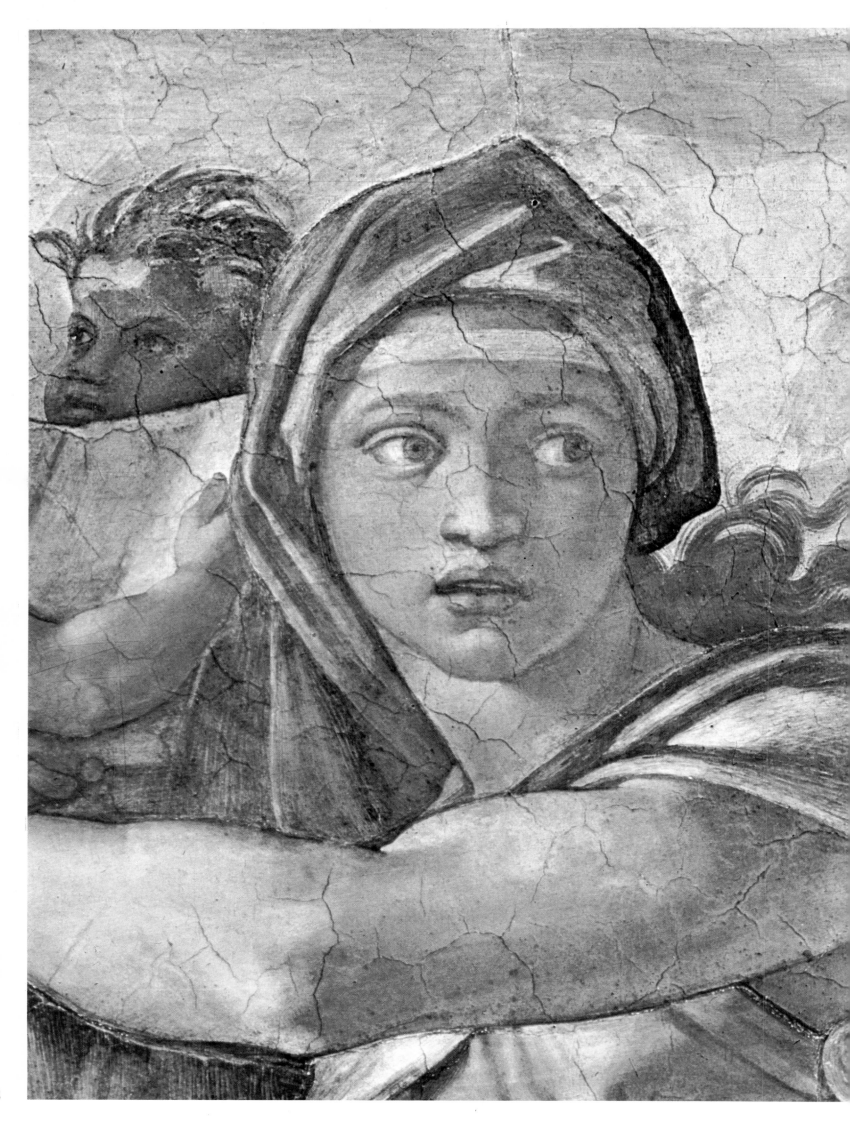

Plate 51
Head of the Delphic Sibyl

Plate 52
The Façade, Church of S. Lorenzo,
Florence

Library which, though started later and worked on at the same time, was finished earlier. What is of interest is that in the chapel Michelangelo was primarily concerned neither with architecture or sculpture, but with a subtle combination of the two. Both the elements were to be considered as one. He saw the wall, not as a surface to be decorated, but as a vital form in itself. The whole chapel was conceived as a complete organic unit. The years spent on the Medici tombs were stylistically important for Michelangelo, and these are the years that mark the final transition from the tradition and order of the High Renaissance to the deeply emotional style of his later years, which we can only call 'Mannerist'. The many disturbances that interfered with his work added to his feelings of tension, while all the time he referred to his madness and melancholy. A mausoleum was not the happiest place for him to be working in at this time.

The chapel is the high point of his middle years, and though in the end he left it unfinished, it tells us much about his increasingly tormented mind and is, in many ways, the most complete of all his works.

Michelangelo intended the chapel to be a place for quiet speculation, cool and isolated, where it would be possible to think

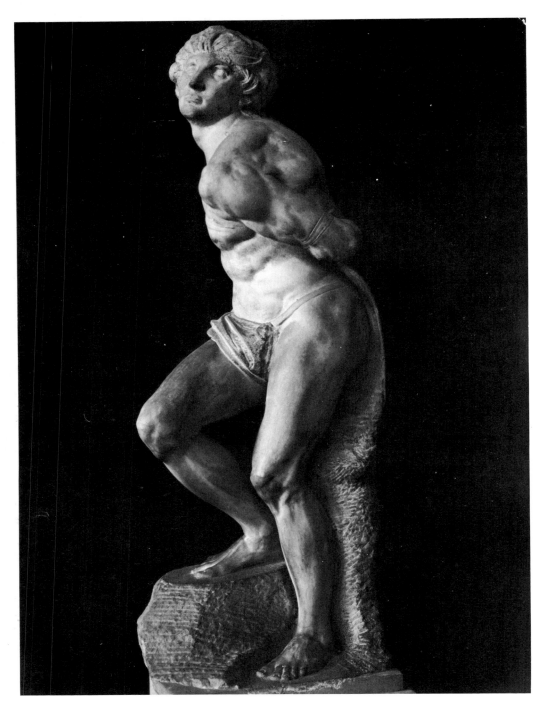

Plate 53
The Struggling Captive
1513
Marble
Height 7 ft (216 cm)
The Louvre, Paris

dispassionately of serious things. It expresses his reverence for the
dead—his own father, Lodovico, died early in 1531 while he was
still at work on it—and, even though we can no longer see it
exactly as he would have wished, it is still possible to experience
the feeling of awe and mystery which the presence of death has for
us all: 'Only in darkness can men be themselves'.

The figures of Lorenzo and Giuliano are not portraits, and
Michelangelo had no intention that they should be. When
questioned about the total neglect of likeness, Michelangelo is said
to have replied that 'in a thousand years nobody would know what
the two Medici had really looked like'; he was clearly concerned
with something else. They are the symbols of man's contemplative
and active lives.

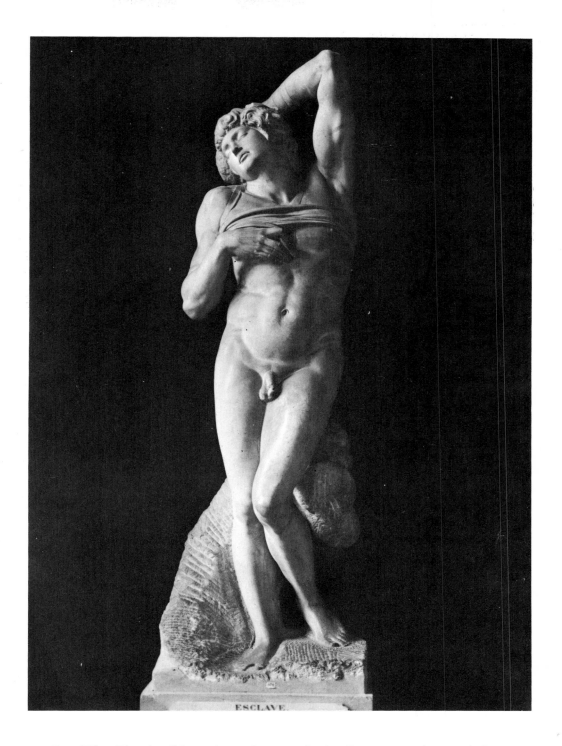

Plate 54
The Dying Captive
. 1515
Marble
Height 7 ft 6½ in (230 cm)
The Louvre, Paris

On *The Tomb of Lorenzo,* the symbol of contemplative life, Lorenzo is deep in thought, the shadow of his helmet designed to fall across his face (plate 57). His finger tugs at his lower lip and he sits easily on his throne. Lorenzo died young and partially insane, but here we see him at the height of his power. Below him are the two allegorical figures of *Dawn* and *Evening*.

Dawn (plate 58) is Michelangelo's first carved female nude, and despite the cool marble, he gives us a sensual woman and we feel the warmth of her body, as she reluctantly and slowly wakes to face a new day. Her breasts thrust outwards, her legs are open and relaxed, and we move instinctively towards her. She seems to raise herself gently to meet us (plate 59).

Michelangelo has seen her in the first moments of waking,

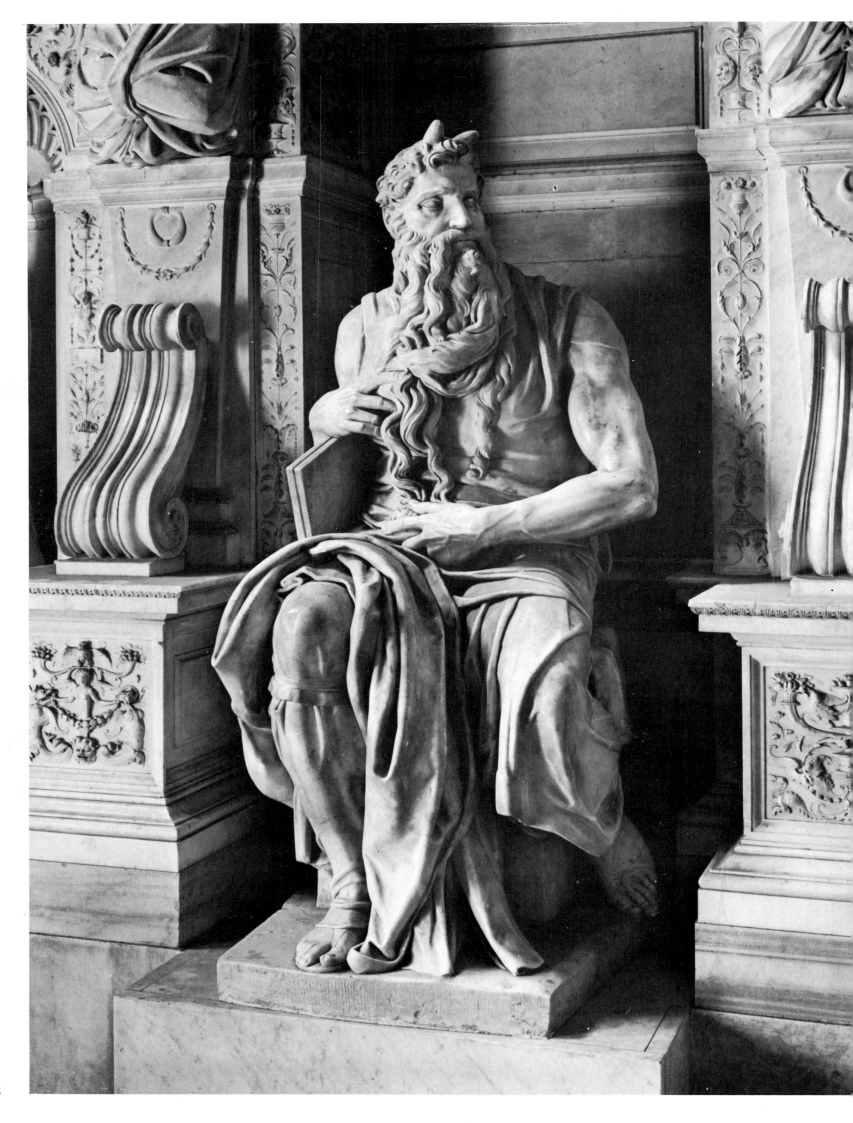

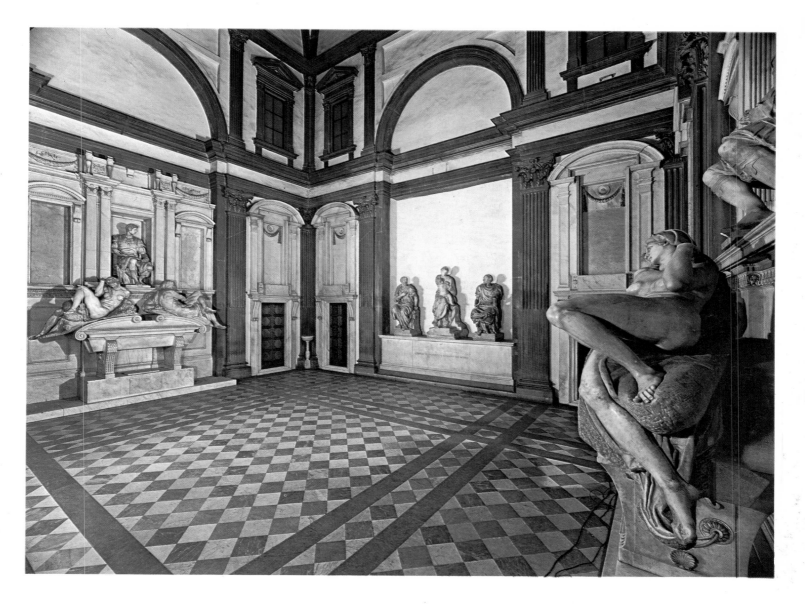

vulnerable and drowsily unaware. She is seen as an object of desire, totally female. She is the most sensual of all his figures and she exists in her own right.

Her companion *Evening* (plate 60) is male and no longer young. He lies relaxed, with a hint of exhaustion, waiting for nightfall, when he will be able to sleep and regain his strength. There is no obvious relationship between the two figures, they are expressions of Michelangelo's state of mind, and it must always be remembered that though they have definite individual characteristics, they are only a part of the total conception.

The Tomb of Giuliano symbolises active life. Lithe, alert and athletic-looking, Giuliano is very much the man of action (plate 61). Bareheaded, he turns to his left and we are able to admire the handsome profile. He, too, died young, and Michelangelo shows him to be a thoughtful, serious–and almost grave–young man. Below him are the figures of *Day* and *Night*.

Day (plate 62) is male, heavily muscled and extremely powerful, with massive shoulders and obviously capable of breaking free from his setting with the utmost ease. Essentially virile, a man in a

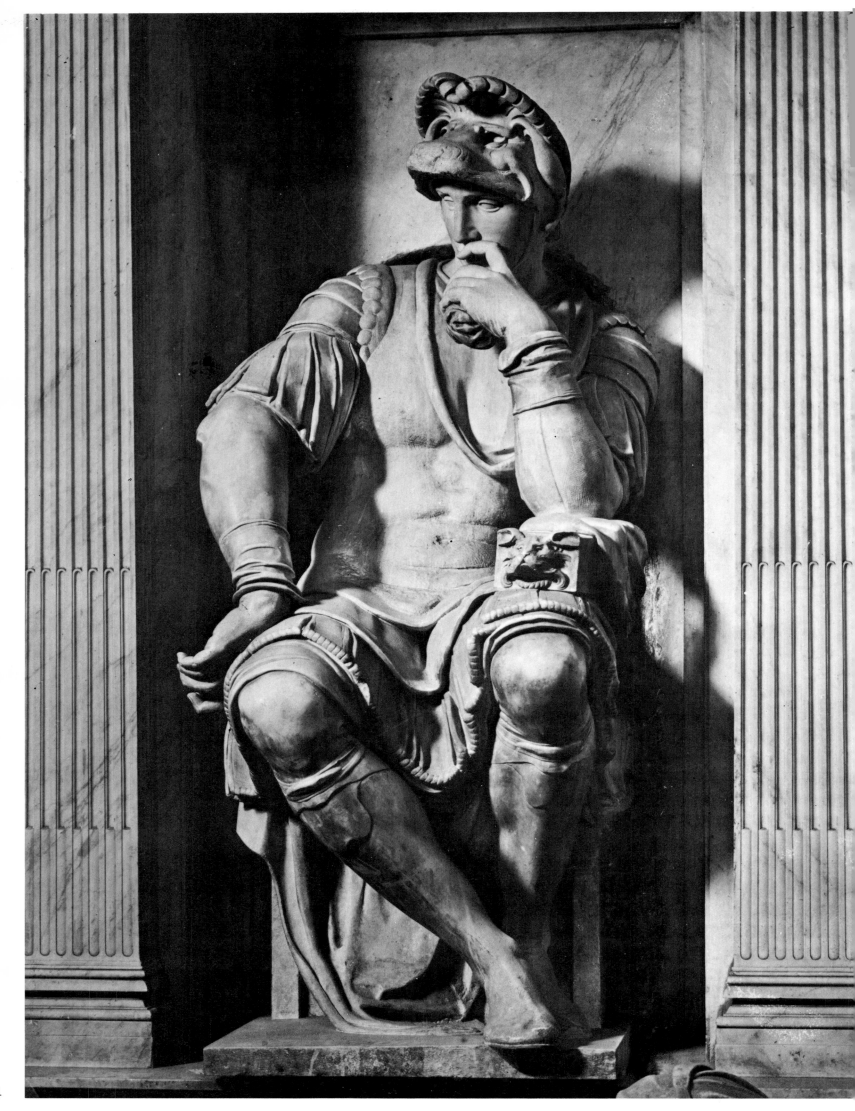

state of total awareness, his are the hours of light and the time for action.

Night (plate 63), on the other hand, is female, but unlike *Dawn*, her body is tired, her breasts sag and her stomach is loose and tired. She sleeps fitfully and seems haunted by disturbing dreams and she is very much alone. We feel no desire to move towards her and she is unaware of our presence. The owl and the sinister mask add to the discomfort we feel, and even Giuliano looks the other way.

In the chapel we are inside time itself, and it is a never-ending story. *Dawn* follows *Night*, then *Day*, then *Evening*, then *Night* again, with no need for an explanation from the artist.

While working in the chapel, Michelangelo wrote the following poem:

Vicissitudes of time can never soar
To where you are, while here we still are crushed
By doubt of joy and uncertainty of war.

By no dark cloud your light is ever hushed,
For our years, numbered, us alone defeat—
Us, tossed about by time and sorely anguished.
Your splendour, oh, no night will ever split,
Nor can the rising morning make more clear
As it does here, where dawn soon turns to hear.

His father had just died, and he is very much concerned with the shortness of life and the suddenness of death. Never did he carve so fluently or with so much feeling.

The so-called *Medici Madonna* (plate 64), originally intended for *The Tomb of Lorenzo* and unfinished, is mainly of stylistic interest.

Vasari's description suggests more agitation than in fact there is, but it does stress the obvious animation of the figure: 'She is seated, with her left leg crossed over her right and one knee placed on the other, while the Child, with his thighs astride the leg that is uppermost, turns in a most enchanting attitude, looking for his mother's milk. Our Lady, holding him with one hand and supporting herself with the other, leans forward to give it to him'.

With its long spiral of contrasting movements, it has all the mannerisms that Vasari loved, and hints at the elegant exaggerations of Parmigianino (plate 65) and Pontormo. From now on we become increasingly aware of this tendency to elongate figures, and accurate anatomical proportion seems to matter less and less.

Though we recognise the unfinished state of the chapel—when he left finally for Rome he 'left statues strewn about'—the

Plate 57
Lorenzo de' Medici, Duke of Urbino
Detail from his tomb
1526–34
Marble
Height of figure 5 ft 10 in (173 cm)
Medici Chapel, S. Lorenzo, Florence

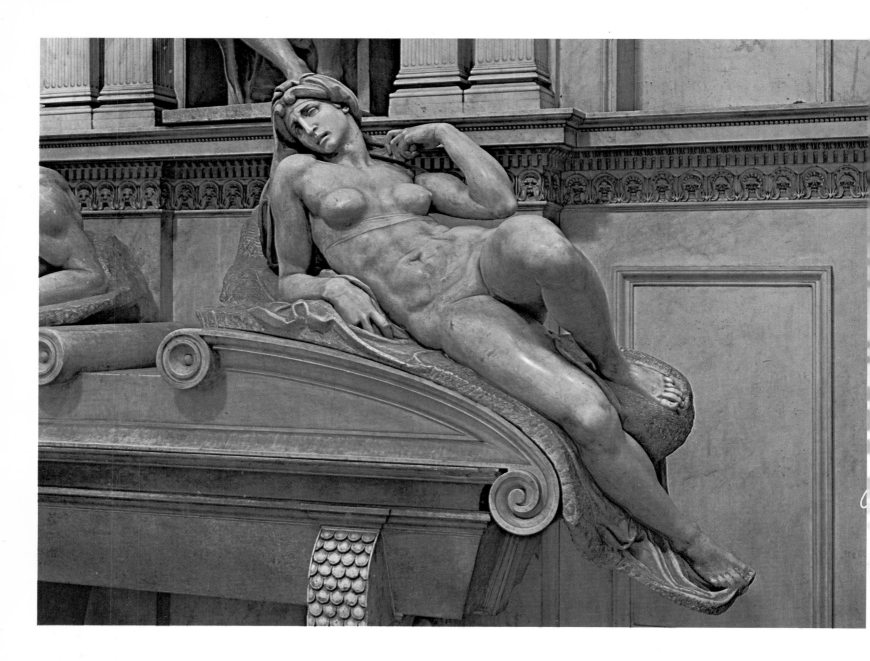

mausoleum comes close to being as Michelangelo intended. It is a total concept, the architecture and the sculpture blending into a complete unit. It is the expression of a state of mind, and in the four allegorical figures we see truly the 'Master of live stone'.

As Burckhardt writes: 'In the four statues the master had proclaimed his boldest ideas on the limits and aims of his art.'

After the death of Leo X, and the short tenancy of the Dutch Pope, Hadrian VI, Giulio de' Medici was elected Pope Clement VII, and it was he who suggested to Michelangelo that he should design a new library to be attached to San Lorenzo to house the famous collection of manuscripts and printed books.

Michelangelo's career as an architect was equally frustrating. He continually complained that it was not his true profession and his whole approach was very much that of the sculptor. He made clay models rather than perspective drawings, and usually made considerable alterations as the work progressed. None of his major designs were complete at the time of his death.

Plate 58
Dawn
Allegory on the tomb of Lorenzo de' Medici
1526–34
Marble
Length of figure 6 ft 8 in (263 cm)
Medici Chapel, S. Lorenzo, Florence

Plate 59
Detail of Dawn

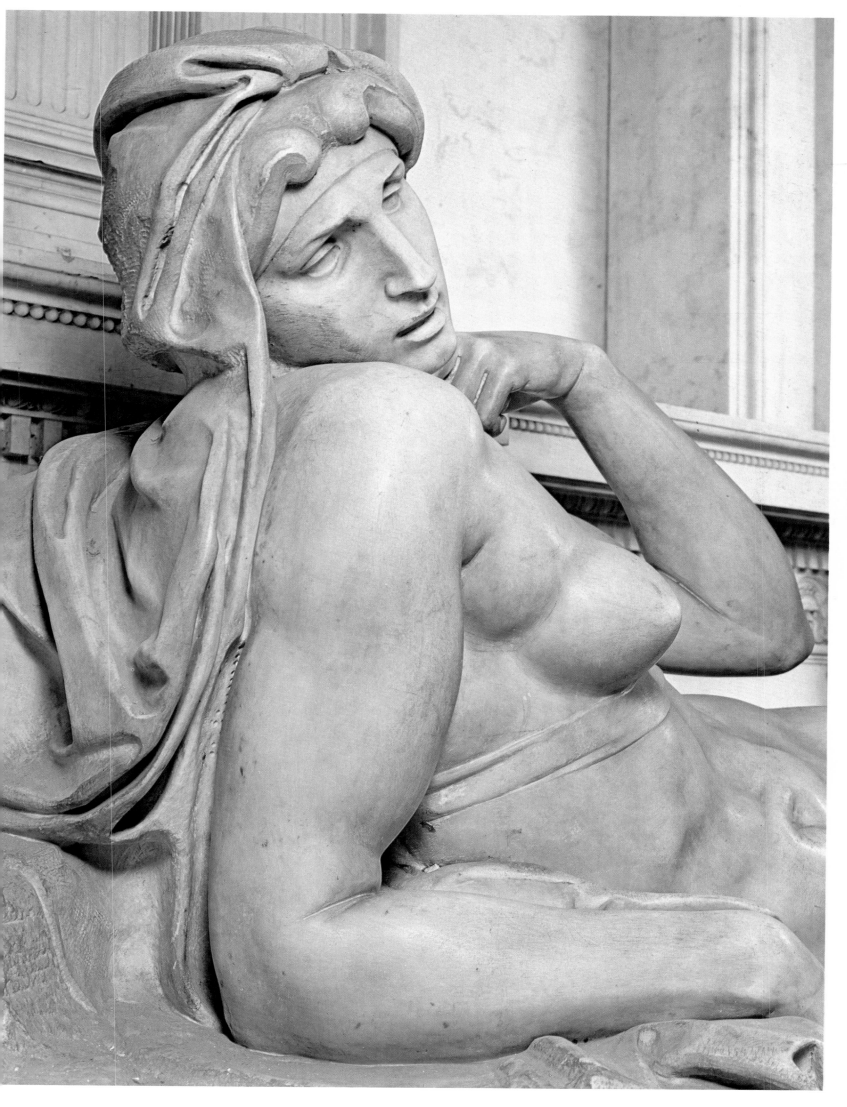

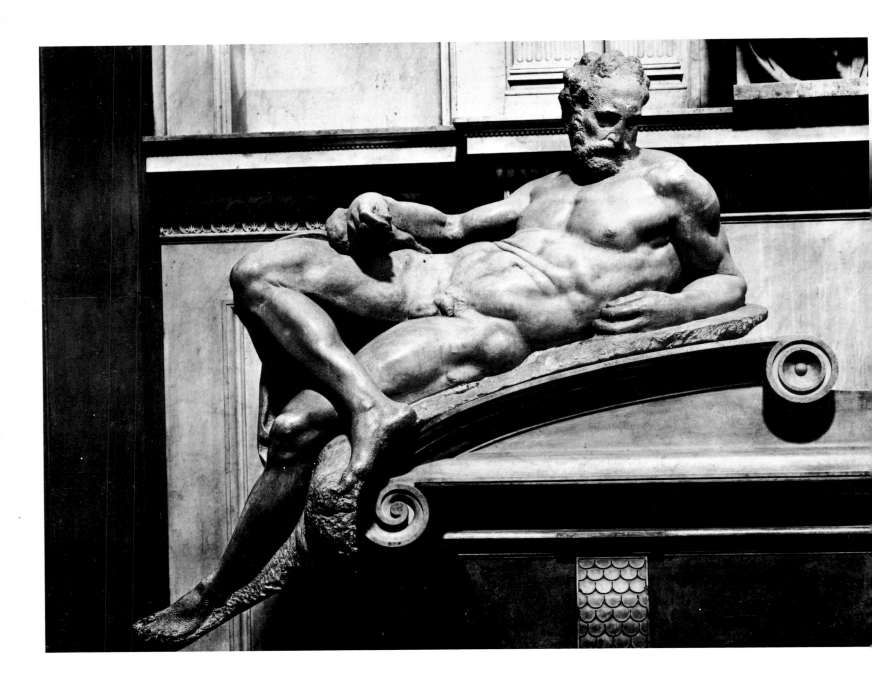

The library is extremely long and narrow, in harsh contrast to the entrance hall, which is exceedingly high. The latter is the same width as the library, which is reached by a deceptively steep staircase which flows towards us and occupies almost the entire space (plate 66).

The site determined the unusual shape, but the whole concept is outrageously unclassical. This is Mannerist architecture, and the treatment of the columns and the introduction of blind windows is no less perverse. The architecture is the decoration and the colour is black, white and grey. Like the Medici Chapel, it is a cool building – icy almost – and there is an air of quiet foreboding.

These were confused and unhappy times for Florence, and Michelangelo seems to have been deeply affected by what was taking place around him: 'And fate sprang forth, mischance or happiness to each man fell, to me the dark time, I know well for it has always been with me since birth!'

Plate 60
Evening
Allegory on the tomb of Lorenzo de' Medic
1526–34
Marble
Height of figure 5 ft 10 in (173 cm)
Medici Chapel, S. Lorenzo, Florence

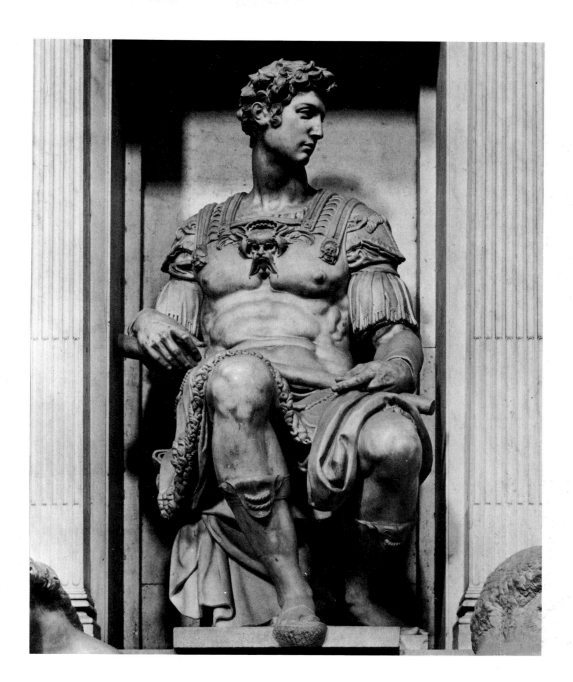

Plate 61
Guiliano de' Medici, Duke of Nemours
Detail from his tomb
Marble
Height of figure 6 ft 4¾ in (195 cm)
Medici Chapel. S. Lorenzo, Florence

It was now that Michelangelo carved the unfinished *Apollo*, intended as a present for Baccio Valori, who had helped him in his reconciliations with the reinstated Clement, and a small crouching figure of a boy, though this was probably the work of an assistant. The lost painting of *Leda and the Swan* also dates from this time.

Of far more interest, however, are the four unfinished *Captives* or *Giants* abandoned by Michelangelo in his workshop when he left for Rome. Probably intended for *The Tomb of Julius,* they mark the end of his final Florentine period and now stand, in poignant contrast to the *David*, in the Accademia. They are particularly interesting in their unfinished state, largely because they show clearly Michelangelo's technique when carving on this scale.

Known as *The Bearded Giant* (plate 67), *The Young Giant* (plate 68), *The Awakening Giant* (plate 69) and *Atlas* (plate 70), they are full of echoes of the past and reflect the struggles and frustrations of both the city of Florence and of Michelangelo himself.

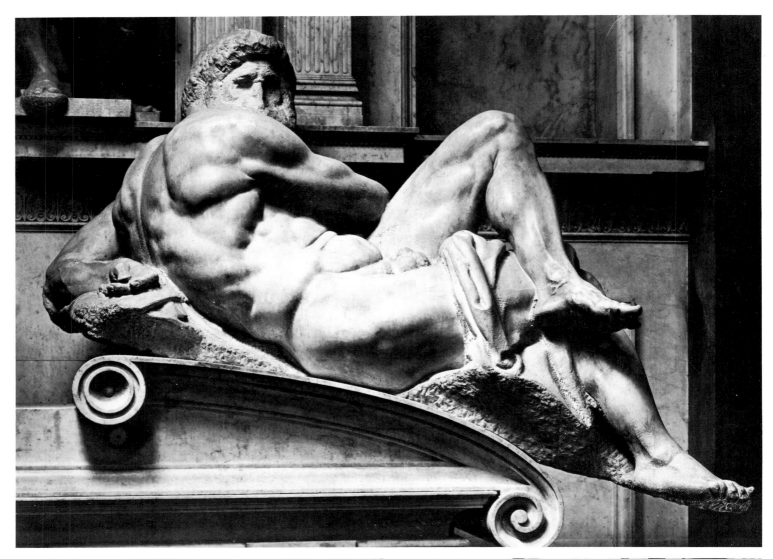

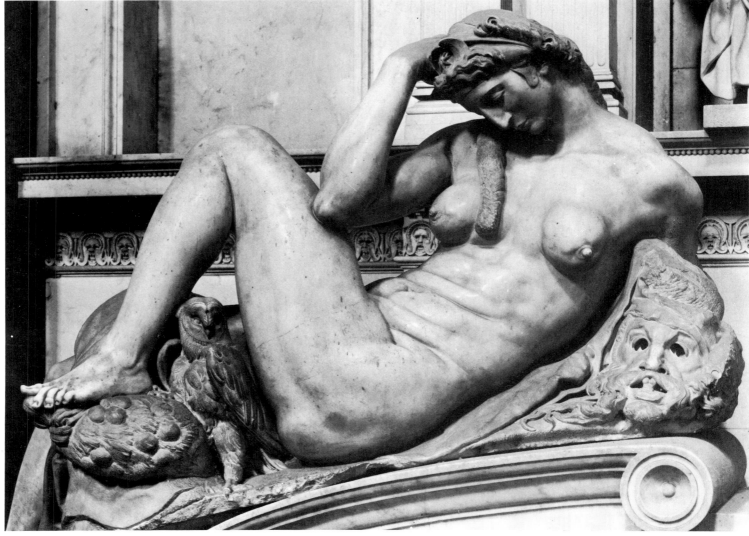

The most problematical of all Michelangelo's figures is the *Victory* (plate 71) about which nothing is certain except that, like *The Captives,* it was found abandoned in the workshop in 1534. It has been suggested that it was intended either for the San Lorenzo façade or *The Tomb of Julius,* but that equally it might have some private, even erotic significance. It shows a naked, somewhat effeminate youth astride his victim, an older man, bent and cowed, whose features bear a marked resemblance to those of the sculptor (plate 72). If, indeed, it is a self-portrait, then it might well have a private, if not necessarily erotic, significance.

In 1532, in Rome, Michelangelo met the young nobleman, Tommaso de'Cavalieri, for whom he developed a deep and lasting affection, and to whom he sent many of his most intimate poems.

To Tommaso de'Cavalieri
This glorious light I see with your own eyes
Since mine are blind and will not let me see.
Your feet lend me their own security
To carry burdens far beyond my size.

Supported by your wings I now am sped,
And by your spirit to heaven I am borne.
According to your will, I'm pale or red—
Hot in the harshest winter, cold in the sun.

All my own longings wait upon your will,
Within your heart my thoughts find formulation,
Upon your breath my words find speech.

Just as the moon owes its illumination
To the sun's light, so I am blind until
To every part of heaven your rays will reach. (*Sonnet XXX*)

It is all too easy to read between the lines and come to an understanding of *Victory*. The young man is Tommaso de' Cavalieri, but with a figure as ambiguous as this, there are many plausible interpretations and no way of resolving the enigma.

On 23 September 1534, Michelangelo arrived in Rome–two days before the death of Pope Clement VII–and never returned to Florence. Clement was succeeded by Alessandro Farnese–Pope Paul III–who, knowing of Michelangelo's earlier acceptance of the commission to paint a *Last Judgement* on the altar wall of the Sistine Chapel, urged him to start work at once.

The Judgement

The Last Judgement (plate 73), a fresco, described as 'a wreck more
sublime than most intact works of art', covers a total area of over
2,000 square feet. It took seven years to complete, and again,
Michelangelo saw it as an interference with his plans to finish *The
Tomb of Julius*. Twenty-five years earlier, when he started on the
ceiling, he had felt exactly the same, but now, as then, he started
work with his usual enthusiasm.

The painting is divided into three main compartments and the
first impression is of a vast whirl of bodies with Christ at the
centre. He is the focal point (plate 75). Next to him is the Virgin.
On their right are the Fathers of the House of Israel, on their left
the Apostles. Together, these figures form the upper arc of the
whirl.

In the corners are the holy Hebrew Women, holy Virgins, Sibyls,
Prophets, Confessors and Martyrs, and above are flights of Angels,
who carry the instruments of the Passion. The whole upper part of
the painting is filled with those already in the Kingdom of Heaven
– those who have been judged.

Christ as Judge is a splendid figure, all powerful, with a broad,
square, muscular body of almost superhuman proportions.
Michelangelo has knowingly exaggerated Christ's physique to
ensure his total domination, not only at the centre of the
composition, but in psychological terms over the other characters.
He is by far the most important, and it is impossible to ignore him
as he makes his judgement with upraised hand.

Immediately below, St Bartholomew – a caricature of Pietro
Aretino – holds the limp, flayed skin of the painter (plate 74). The
whole conception is a terrible indication of the artist's state of
mind; there is little joy even for the few who are saved. This really
is Dante's *Inferno*. On his right the souls rise hopefully and the
Virgin half turns towards them in pity, but even she flinches at the
thunder of her son's judgement (plate 76). On his left the damned
fall slowly away down towards the gaping mouth of hell. Here is
Death, and Michelangelo shows her shrouded, with eyes gaping
emptily from her skull head (plate 77). All is noise and the fat,
bloated, trumpeting angels blast out their warning (plate 78).

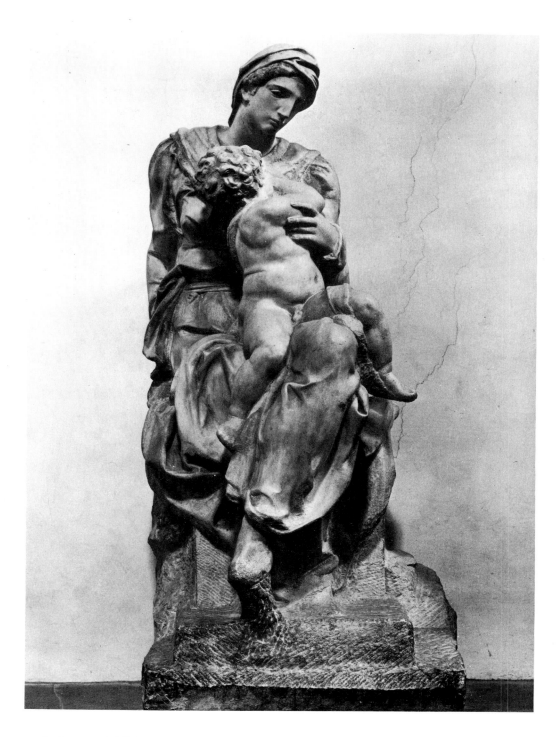

Plate 64
The Medici Madonna
Marble
Height 7 ft 5⅜ in (226 cm)

It is a terrifying story, told by a man at the height of his descriptive powers and believing utterly in what he is telling us.

The work is full of carefully drawn characters representing all aspects of humanity, and even the devils have their own personalities.

Full of real terror, Pope Paul, when he saw the figures of Minos (plate 79), the Prince of Hell and the horrific ferryman, Charon (plate 80), 'his eyes red like a burning brand who thumps with his oar the lingerers that delay, and rounds them up and beckons with his hand' (Dante), is supposed to have cried out, 'Lord charge me not with my sins when Thou shalt come on the Day of Judgement'. Michelangelo is said to have been delighted.

Badly smeared by the smoke from the altar candles, the work

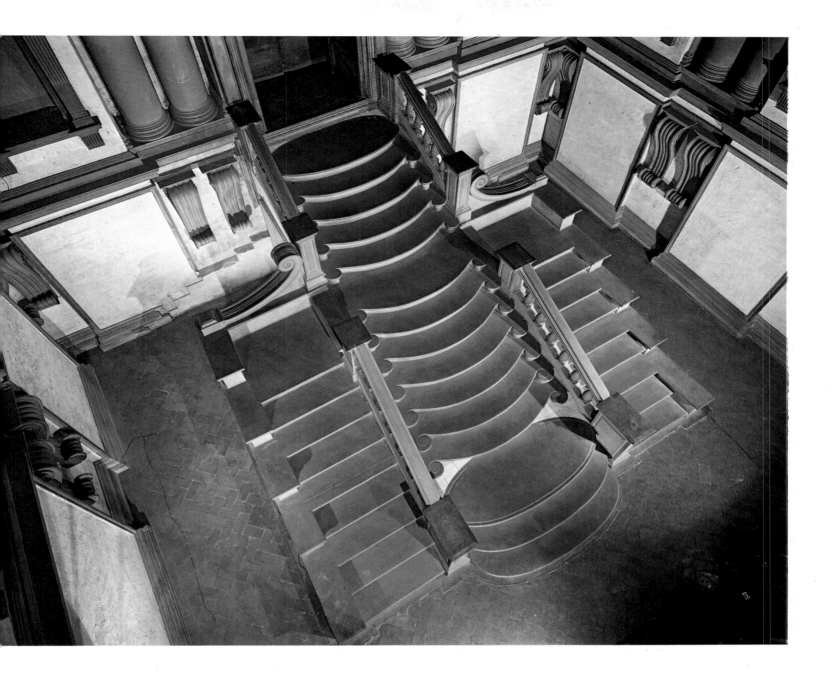

Plate 65
Altarpiece: Madonna and child with St John the Baptist and St Jerome
Parmigianino (1503–1540)
1527
Wood, arched top
11 ft 3 in × 4 ft 10½ in (342.9 × 148.6 cm)
The National Gallery, London

Plate 66
The Stairs in the Vestibule
1558–59
Marble
Biblioteca Laurenziana, Florence

has suffered over the years, and what we see now is very much a 'mutilated masterpiece', but it is only Michelangelo's actual painting that has been seriously damaged. We can still appreciate the splendour of the original conception and the design is his. There have been subsequent major restorations, and some of the repainting is particularly disastrous. In 1555, after the election of Pope Paul IV and amidst the wave of puritanism which immediately followed the Council of Trent, the nudes were ordered to be clothed. Michelangelo, when told what was to be done, sent the following message: 'Tell his Holiness that this is a small matter – let him look to the setting of the world in order; to reform a picture costs no trouble.'

Daniele de Volterra, known ever after as '*Il Brachettone*' – the breeches-maker – made the painting respectable.

With his *Last Judgement* Michelangelo influenced the course of Italian art, both in theory and form. The nude figure, especially in

difficult poses, became one of the main sources of Mannerist art, and Michelangelo's imitators worked themselves into veritable frenzies trying to capture his spirit. This spirit, though it encouraged others to lift their art to a new height, also, unfortunately, forced lesser men to overreach themselves. His so-called followers, among them Sebastiano del Piombo, were full of loud dramatic gestures, but the more they tried, the more elusive the 'sweet strength' became. What Michelangelo learnt from Giotto and Masaccio was a basic simplicity, to make a point as forcibly and accurately as possible, and like them, he had no use for empty statements. To the last he was a Florentine; his was the vision of Dante.

On Dante Alighieri
It is not possible to say how much
We owe him, because his splendour blinds
Our eyes. Simpler it is to blame those minds
Too small to honour him, to sense his touch.

He did not fear to plumb to places where
Failure alone survives. But this was done
For our example. Always he was near
To God. Only his country dared to shun

His greatness. Her ingratitude at last
Turned on herself. As proof of this, observe
How always to the perfect sorrows fall

Most painfully. To those who are the best
Most ill occurs. Dante did not deserve
Exile; his equal never lived at all. (*Sonnet II*)

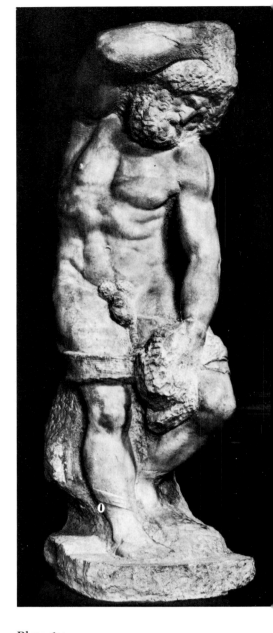

Plate 67
The Bearded Giant
1530–33
Marble
Height 8 ft 8¼ in (266 cm)
Accademia, Florence

Final Years

Plate 68
The Young Giant
1530–33
Marble
Height 8 ft 6¾ in (261 cm)
Accademia, Florence

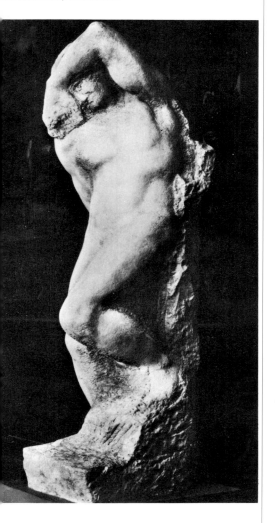

While he worked on *The Last Judgement*, Michelangelo was free of all his obligations to other patrons, but now the problem of *The Tomb of Julius* arose again. Much to his relief, a fifth and final contract was signed, in which he was required to provide only three statues of his own making. Raffaello da Montelupo (1505–67) would supply the others.

One was to be the already finished *Moses*. The other two the half-finished *Captives* which, however, proved hopelessly out of scale in the new reduced design. He took the opportunity to suggest that they should be replaced by two new figures–they were, in fact, started–which would follow the concept of the Medici Chapel and symbolise the active and contemplative lives. They would fit into the niches on either side of the *Moses*, which now was to be the centre-piece. These figures, known as *Rachel* and *Leah*, have none of the anger of the Sistine Chapel and are full of the tenderness of the early *Pietàs*.

Rachel (plate 83), the symbol of the contemplative life, has a sweetness reminiscent of Raphael's work, and all the easy, natural qualities of accepted beauty. The slow turn of her body under the long flowing drapery leads to the upturned head and the serene expression on her face. Her hands clasped in front of her, fingers gently touching, she reminds us of Bernini's St Theresa in the emotion she arouses.

The equally gentle, older sister *Leah* (plate 84), the symbol of active life, is beautiful in a different way. She stands poised and confident, as though well capable of putting thought into action without much hesitation. Strongly built, there is something of the athlete about her. As far as Michelangelo was concerned, *The Tomb of Julius* (plate 82) was finished–the tragedy was over. It was erected in S. Pietro in Vincoli–where it still stands– in 1545, exactly forty years after he had first discussed it with Julius, its main attraction being the magnificent *Moses*.

The bust of *Brutus* was carved about this time, but it is a minor work, certainly finished by someone else, and has none of the qualities we associate with Michelangelo's later works.

After the success of *The Last Judgement*, Pope Paul III asked Michelangelo to paint two large frescoes for his own chapel – the Cappella Paolina. The subjects were to represent *The Conversion of St Paul* and *The Crucifixion of St Peter*. They were painted concurrently with all his other projects and not completed until he was seventy-five years old. They each measured some 400 square feet, and Michelangelo certainly painted them himself.

Opinions differ as to their merit, and they are in very poor condition, having been badly damaged by fire and quite drastically overpainted. They were restored in 1933 when, with the greater understanding of the Mannerist intentions, they were more fully appreciated.

In *The Conversion of St Paul* (plate 85) we have a confusion of opposing movements and everyone seems to be rushing off in different directions. We never quite know where we are in relation to anything else, and the effect is most disconcerting. God and the horse pull against each other, Paul floats above, rather than rests on the ground, and there is a worrying lack of consistent scale. In fact, all the attractions of Mannerism are here, and equally all the weaknesses.

Similarly, in *The Crucifixion of St Peter* (plate 86) we have all the strength of the individual figures in the Sistine Chapel, but here Michelangelo seems incapable of blending them together into coherent groupings. The heavy cross slashes through the middle of the painting and St Peter does not look too distressed. In this painting, in particular, there is some very unhappy, over-dramatic repainting, and some of the figures fairly ogle us to draw our attention to them.

It is difficult to see them as they once might have been. In their present condition they are far from successful. Even if we allow Michelangelo's preoccupation with other things, it is surprising that so soon after the aggressive '*Terribilita*' of *The Last Judgement* he should produce what have been unkindly, but not unjustly, called 'these leaden ballets'.

When Michelangelo was just over sixty years old, he met Vittoria Colonna, the widowed Marchioness of Pescara, herself a woman of fifty. Their famous friendship lasted until her death in 1547.

Known for her grave intellectual qualities, and at the time considered the foremost poetess in Italy, her circle included many of the leading liberal and reforming Catholics, and Michelangelo's thinking was deeply influenced by her. On this pious and accomplished woman he poured out much of the tenderness and devotion which he had kept pent up for so long.

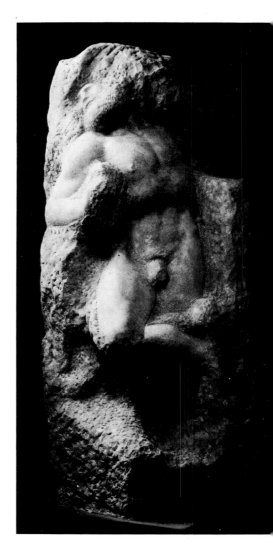

Plate 69
The Awakening Giant
1530–33
Marble
Height 9 ft (274 cm)
Accademia, Florence

Plate 70
Atlas
1530–33
Marble
Height 9 ft 1½ in (278 cm)
Accademia, Florence

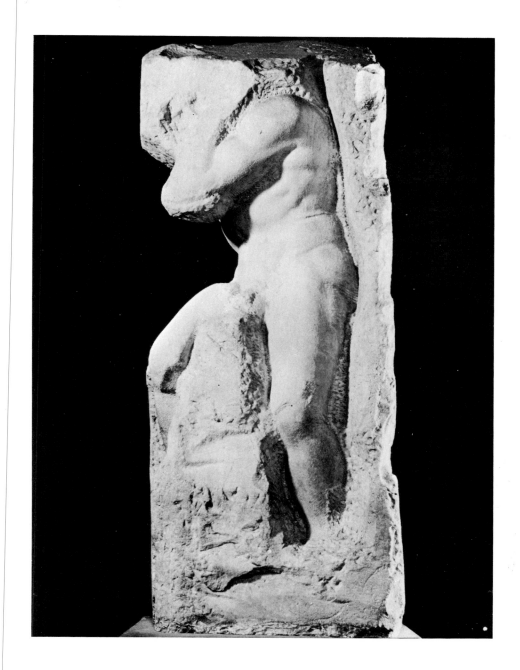

To Vittoria Colonna

To be more worthy of you, Lady, is
My sole desire. For all your kindness
I try to show, with all I have of art,
And courtesy, the gladness of my heart.

But well I know that simply by my own
Efforts I cannot match your goodness. Then
I ask you pardon for what's left undone,
And failing thus, I grow more wise again.

Indeed, I know it would be wrong to hope
That favours, raining from you as from heaven,
Could be repaid by human work so frail.

Art, talent, memory, with all their scope
Can never pay you back what you have given.
At this, a thousand tries would always fail. (*Sonnet XIII*)

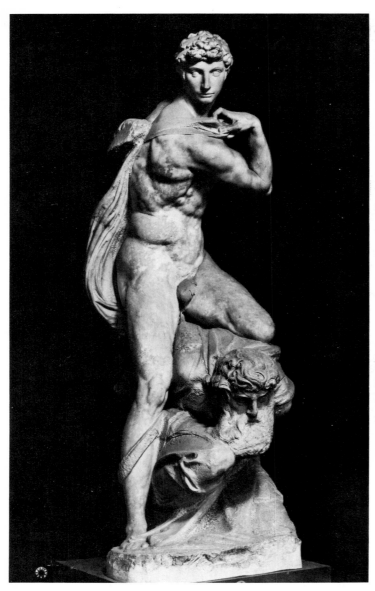

Whatever popular writers have hinted at, their friendship was on a truly platonic level and the significance of her affection was that in times of disappointment and bleak despair she gave him hope. There is no parallel with Dante and Beatrice. Michelangelo only resembles Dante in his warmth, and like Dante, his mistress is Death.

Vittoria's correspondence with writers and scholars is her direct memorial, but her friendship with Michelangelo is now her only real claim to fame. In the last thirty years of Michelangelo's life his work was exclusively religious, and the emphasis on what had always been a strong element in his character can be partly attributed to his extreme sadness at her death.

Condivi writes: 'He greatly loved the Marchioness Pescara, of whose divine spirit he was enamoured . . . He loved her so that I remember to have heard him say he regretted nothing except that when he went to visit her upon the moment of her passage from this life, he did not kiss her forehead or her face, as he did kiss her hand.'[1]

Plate 71
Victory
1525–30
Marble
Height 8 ft 7½ in (263 cm)
Palazzo Vecchio, Florence

Plate 72
Victory detail

Plate 73
The Last Judgement
1536–41
Fresco
48 × 44 ft (14.6 × 13.4 m)
The Sistine Chapel, The Vatican, Rome

[1] Anthony Bertram, *Michelangelo*, Dutton-Vista 1964, p.145.

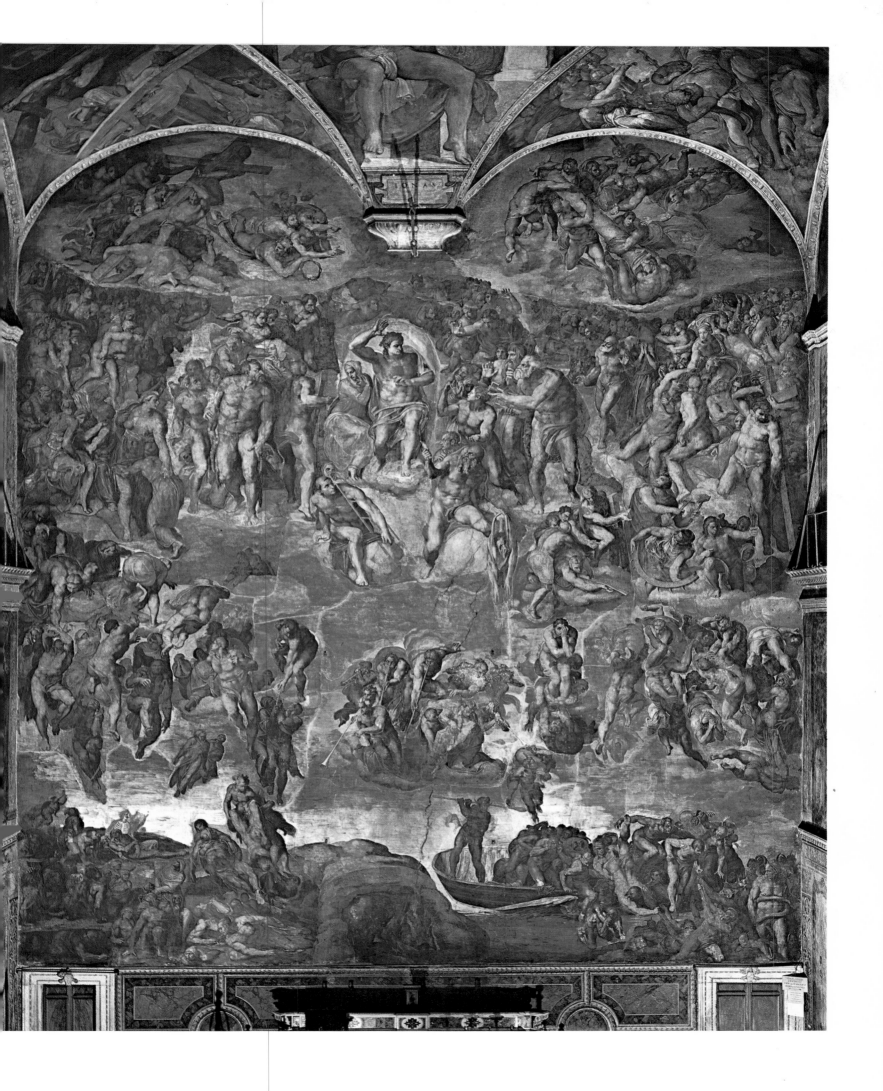

On the death of Vittoria Colonna

When she who was the cause of all my sighs
Withdrew both from the world and from my eyes,
Nature itself was full of shame to see
Men weeping at the loss of such as she.

But nature may not boast as once it did.
Not it but death has quenched this sun of suns.
But death by love is conquered; love has laid
The glorious creature with the blessed ones.

Thus death, so pitiless, is now deceived;
It has no power to harm such pure perfection,
Or dim her triumph, as it once believed.

History is shining with her soul's reflection
Since she, though dead, lives more abundantly,
She, who would never leave us willingly. *(Sonnet LXII)*

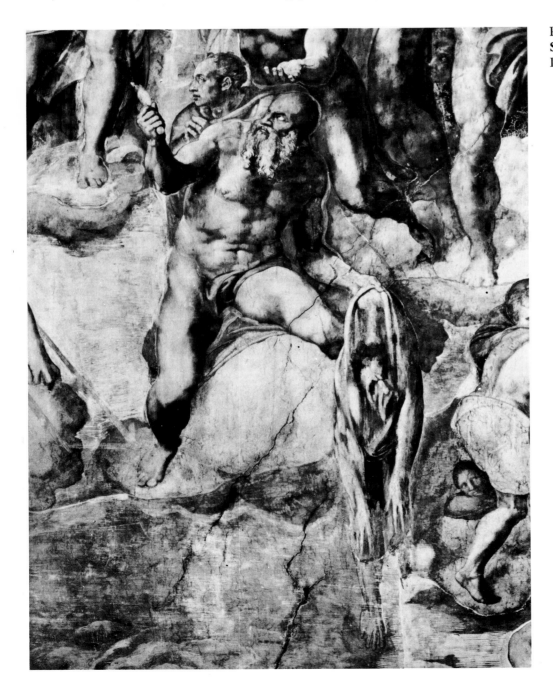

Plate 74
St Bartholomew Holding his Flayed Skin
Detail from The Last Judgement

Michelangelo worshipped beauty: 'Beauty has a hold unbreakable upon my eager heart':

. . . Dear God, I call and plead with you alone,
For only you can help my blinding pain;
You only have the power to sustain
My courage. I am helpless on my own . . . (from *Sonnet LXXII*)

Your loveliness was never meant to die
But wrought in heaven to be released among
Men on the earth. Thus I exhausted lie . . . (from *Sonnet XLIX*)

The occasional and informal character of Michelangelo's poetry, freely written and sent to his friends without thought of publication – Vittoria, Vasari and Tommaso each received some of his most pathetically beautiful love poems – reminds us of the constant struggle against his temperament.

He was easily possessed and just as easily overwhelmed. The importance of the poetry, irrespective of the merit of the verse, is that it gives a clear insight into his mind. Written with passionate innocence, it is here that he is most likely to bare his soul.

There is no lower thing on earth than I
Conceive myself to be when I lack you.
My weak and tired spirit makes me sigh
For pardon for all things I've failed to do.

Stretch down to me, Oh God, that powerful chain
That knots all heavenly gifts. Such faith and trust
Are what I long forever to attain;
It is my fault I am not fully blest.

The more I think of faith, more rare and good
It seems, and even greater may it be
Since all the world depends on it for peace.

You never were a miser of your blood:
If Heaven is locked to every other key,
What kind of gifts of mercy, then, are these? (*Sonnet LXVII*)

Michelangelo was the subject of two biographies completed and published in his own lifetime. The first biographer was Vasari (plate 87), who concluded the first edition of his *Lives of the Painters, Sculptors and Architects* – written probably in 1547 and published in 1550 – with the life of one living artist – Michelangelo. This gives the most complete biography of any artist up to that time and is a trustworthy guide to the feelings of his contemporaries.

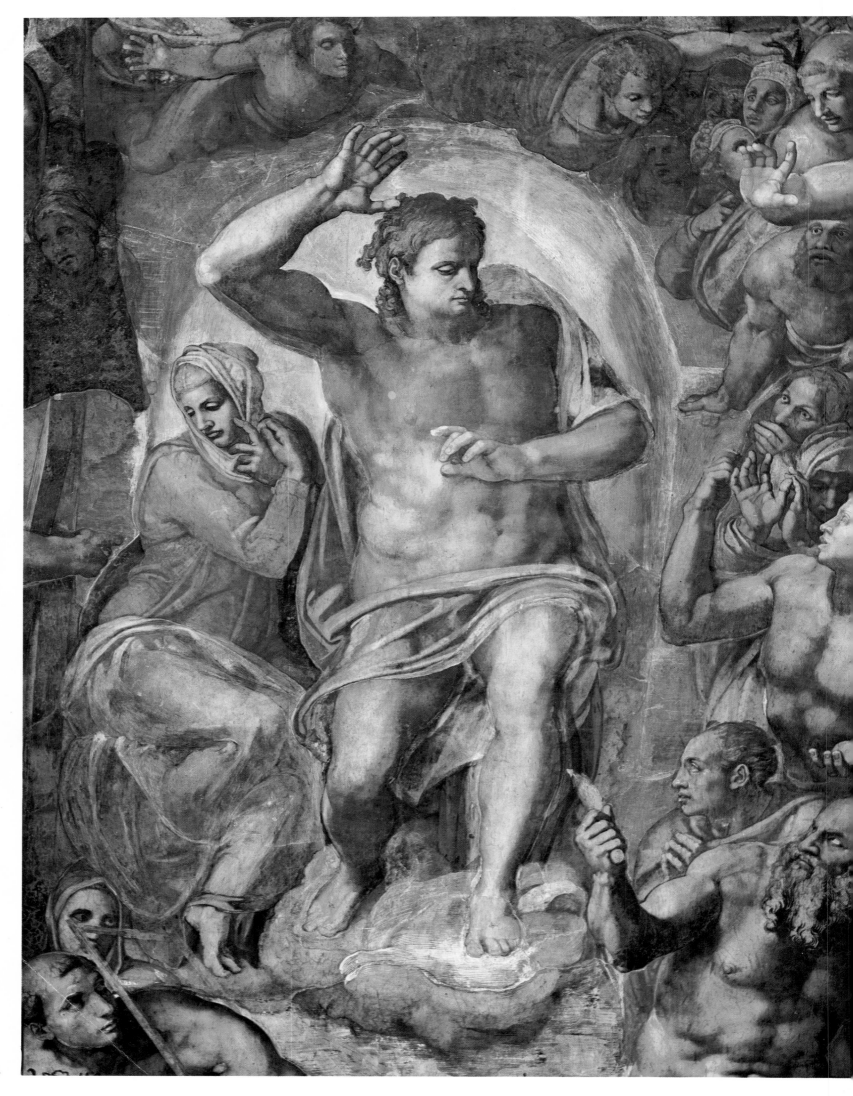

Giorgio Vasari (1511–74) idolised Michelangelo as an artist and studied under him for a while before he left for Rome. Later he worked with Andrea del Sarto (1486–1531) and became very much a Mannerist painter, with a light decorative style but little feeling for form and space. It was he who eventually designed Michelangelo's tomb in Santa Croce. Vasari was careless with his dates, and many of his attributions are open to question, but the *Lives*, a second enlarged, revised edition of which was published in 1568, is most readable and conveys very well the revolutionary feeling of what happened to Italian art between the fourteenth and sixteenth centuries. In its way a work of art itself, his *Michelangelo* is written with great affection.

Vasari wrote: 'For the sake of truth and because of the debt I owe to his love and kindness, I have set myself to write many

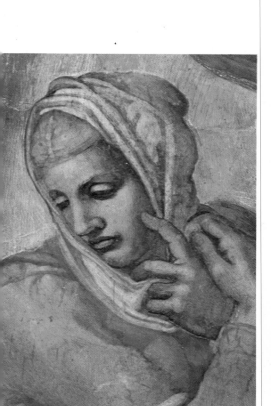

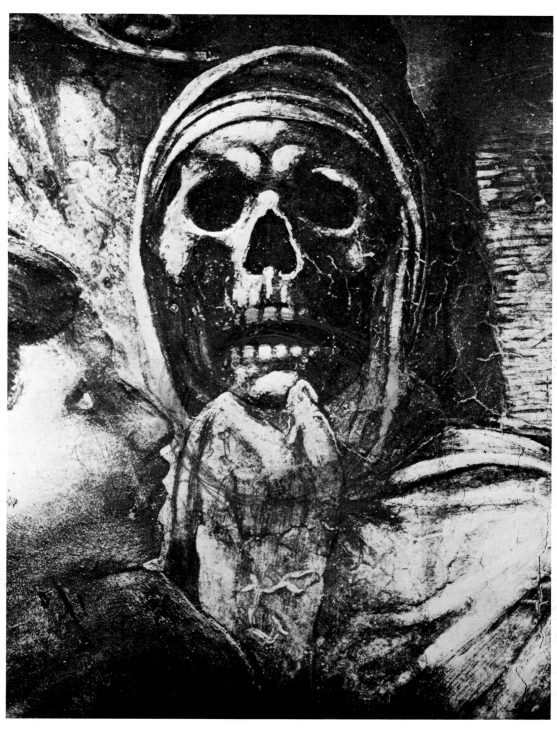

95

things about him and all true, which many others have failed to do.'

He sees Michelangelo as a Florentine painter, sculptor and architect, as an artist 'who would be skilled in each and every craft, whose works alone would teach us to attain perfection (by correct drawing and by the use of contour and light and shadow, so as to obtain relief in painting) as having the knowledge of true moral philosophy and the gift of poetic expression so that everyone might admire and follow him as their perfect exemplar in life, work, and behaviour and every endeavour, and he would be claimed as divine.'

Over-effusive and perhaps embarrassing for the subject of his obvious homage, there is no doubt that Vasari's intentions were strictly honourable.

The second biographer, Ascanio Condivi (*c.* 1525–74), also a pupil of Michelangelo, in 1553 produced a biography promoted by the artist himself and intended to correct what he considered to be errors made by Vasari in the *Lives* and to shift the emphasis of his career in a direction he thought more desirable. Ironically, though not surprisingly, this is far less accurate. The following sonnet written by Michelangelo to Vasari puts the picture into truer perspective:

To Giorgio Vasari on 'The Lives of the Painters'
With pen and colours you have shown how art
Can equal nature. Also in a sense
You have from nature snatched her eminence,
Making the painted beauty touch the heart.

Now a more worthy work your skilful hand,
Writing on paper, labours and contrives—
To give those who're dead new worth, new lives,
Where nature simply made, you understand.

When men have tried in other centuries
To vie with nature in the power to make,
Always they had to yield to her at last.

But you, illuminating memories,
Bring back to life these lives for their own sake,
And conquer nature with the vivid past. (*Sonnet XI*)

It was in a deeply religious mood, partly due to his friendship with Vittoria Colonna, and partly due to his great grief at her death, in which he did some of his finest architectural work and made his last sculptures.

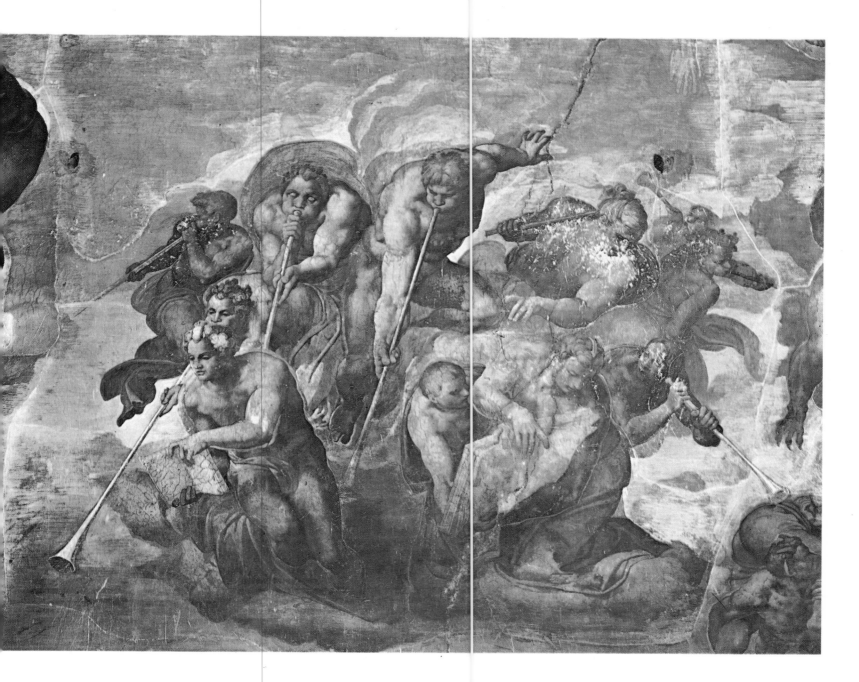

Angels Trumpeting
Detail from The Last Judgement

Michelangelo's later architectural work in Rome looks forward to the complicated schemes realised by the seventeenth-century Baroque architects. In many ways this is where his heritage lies. More than in any of his so-called followers, it is Gianlorenzo Bernini (1598–1680) (plate 88), architect and sculptor, who is his true descendant. Now, nearly seventy years old, he started on a whole series of architectural schemes culminating in the greatest of them all–St Peter's.

First, he reorganised the Capitol to provide a suitable setting for the antique statue of Marcus Aurelius. Oval in shape, a novelty in itself, and flanked by the Palazzo dei Conservatori and the Palazzo del Senatore, it was intended to provide an impressive arena for outdoor ceremonies (plate 89). He redesigned the fronts of the two buildings, neither of which were finished before his death. The most important feature of them is the use of a giant order which reaches to the full height of the building. There is a decorative

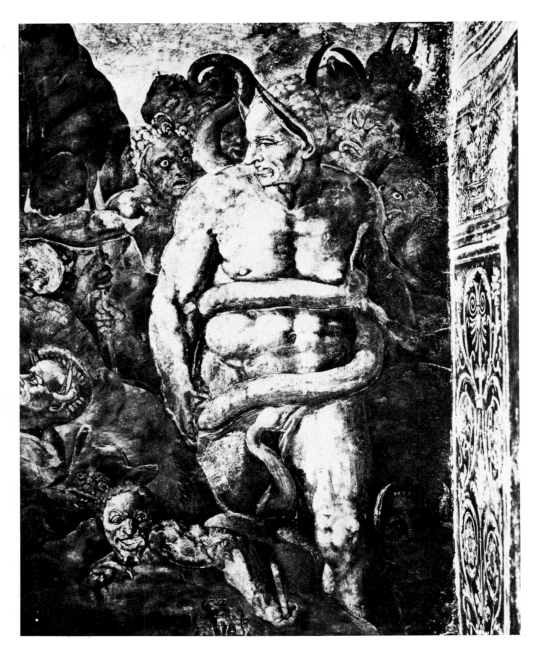

Plate 79
Minos
Detail from The Last Judgement

pattern laid into the piazza, and the whole complex is reached by a gigantic staircase.

He completed the unfinished Palazzo Farnese, redesigning the top storey and giving it a magnificent Florentine cornice, and planned a vast garden which would link it with the Villa Farnesina on the other side of the river Tiber. Very Baroque in concept, this scheme came to nothing.

By far the most important architectural commission was for the completion of St Peter's (plate 90), on which he worked 'for the love of God and without a fee' from 1546 until his death. This church was begun by Donator Bramante (1444–1514) and continued by Antonio da Sangallo (1483–1546). Michelangelo announced his intention of reverting to some degree to Bramante's concept of a centrally-planned church. He greatly modified the latter's plan, and the church, as it stands today, owes more to Michelangelo than to any other single architect. The interior

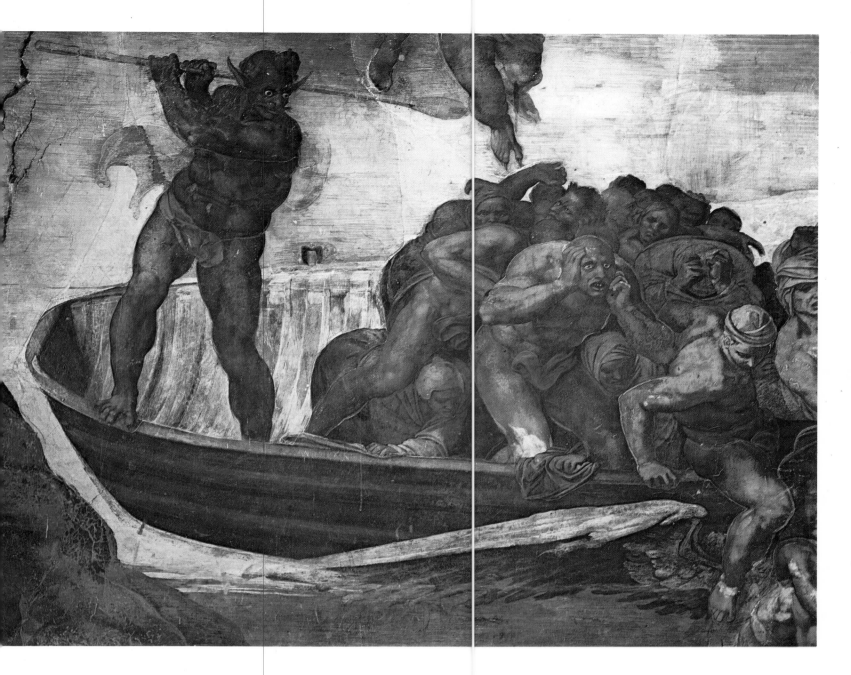

remains as he left it, but the overall effect has been much changed by later decoration (plate 91). The extension of the nave and the entrance façade were added by Carlo Maderna (1556–1629) in 1607. The dome, which was completed by Giacomo della Porta (1541–1604), according to Vasari to the 'satisfaction of Michelangelo's friends and the whole of Rome', was designed by him and the drum is his. The whole concept is on a colossal scale and the summit of the dome is 452 feet high.

Sometime before 1550, when it was mentioned by Vasari, Michelangelo began work on the *Pietà* (plate 93) now in Florence Cathedral. It is a dramatic piece marred only by the poorly carved Magdalen, the work of Tiberio Calcagni (1532–65), to whom the *Pietà* was given, after Michelangelo, finding the marble faulty, had broken Christ's left leg and abandoned it. Calcagni died before he could do too much damage.

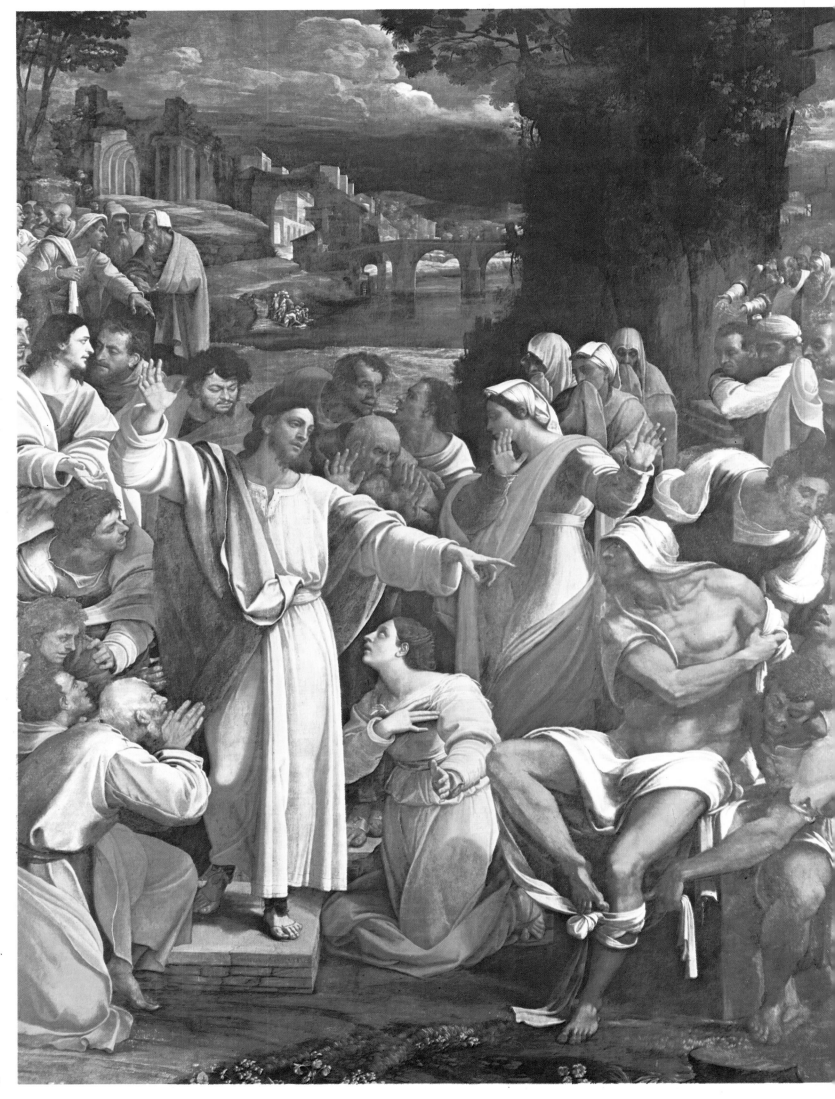

Plate 81
The Raising of Lazarus
Sebastiano del Piombo (1485–1547)
1517–19
Wood, transferred to canvas in the 18th
century and remounted on board in 1966
12 ft 6 in × 9 ft 6 in (381 × 290 cm)
The National Gallery, London

Vasari writes: 'At this time Michelangelo worked on it almost every day as a pastime. At last he broke the stone, probably because it contained veins of emery and was so hard that the chisel struck sparks from it; perhaps also because his criticism of his own work was so severe that nothing he did satisfied him. For this reason, to tell the truth, there are few finished works by him from his late period, when he had reached the highest maturity of his artistic power of creation. His finished sculptures all date from his early period.'

Intended for his own tomb, it is likely that he carved it in a mood of deep despair. Vasari is adamant that the hooded figure of Nicodemus which dominates the group, is a self-portrait (plate 94). The mother tries vainly to support the sagging body, but the weight proves too much for her. Christ's leg buckles and Nicodemus takes some of the strain.

. . . Painting and sculpture cannot any more
Quieten the soul that turns to God again
To God who, on the cross, for us was set. (from *Sonnet LXV*)

Michelangelo feels himself close to Christ, participating in the Passion and he carves with love: 'In order to represent in some degree the adored image of Our Lord, it is not enough that a master should be great and able. I maintain that he must also be a man of good conduct and morals, if possible a saint, in order that the holy ghost may rain down inspiration on his understanding.'[1]

In this piece we talk less about the fine carving and the delicate detailing, more about the mood and the compassion. We marvel at the way a lump of faulty marble could contain such depth of feeling. When we look at the ludicrous little *Magdalen* we see a piece of sculpture, a small statue, the rest we take for granted and hardly notice at all.

The spirit of the late *Pietàs* is so different from the early *Rome Pietà* that, even in *The Palestrina Pietà* (plate 95) which, though probably started by Michelangelo, was certainly finished by someone else, we sense the underlying emotion. We like to feel it is his, but find the obvious distortion too much to take. The body is far too heavy, and Michelangelo always handles his weight so well. The sagging figure defies any attempts to support it and the little legs are totally inadequate.

Michelangelo is essentially articulate. He is able to describe the slightest change of stress or direction, and his understanding of the moving human body is without parallel. Both Leonardo and Raphael were great draughtsmen, but even they lacked his tremendous strength. His drawing is incisive and straight to the

1. R. J. Clements, *Michelangelo, A Self Portrait*, New York University 1967.

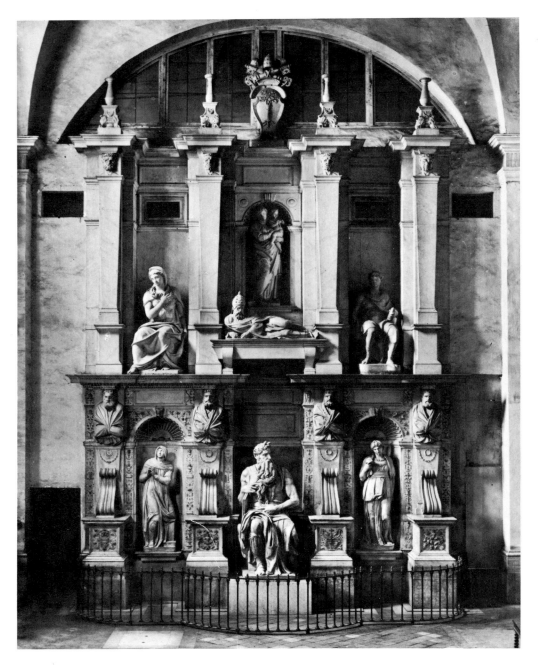

Plate 82
Tomb of Julius II
1505–45
Marble
S. Pietro in Vincoli, Rome

Plate 83
Rachel
Detail from the tomb of Julius II
1542
Marble
Height 6 ft 5½ in (197 cm)
S. Pietro in Vincoli, Rome

point and he is never satisfied, drawing and re-drawing until the form is accurately described to his satisfaction.

In his last years Michelangelo produced a series of drawings on the theme of the Crucifixion (plates 96, 97). They were drawn during the time of his intense religious conviction and show clearly not only Christ's suffering, but the pain of those around him at the end. They are full of agony, as though he wants us to share his personal despair. They offer us a direct contrast to the earlier crucifix of plate 98. A further contrast is provided by the triumphant Risen Christ of plate 100.

The last *Pietà* of all is carved in the same spirit. Started before *The Florentine Pietà*, he was working on it six days before his death. Writing to Vasari he says: 'No thought is born in me in

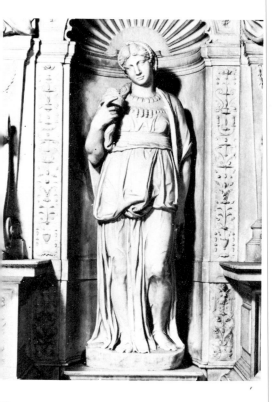

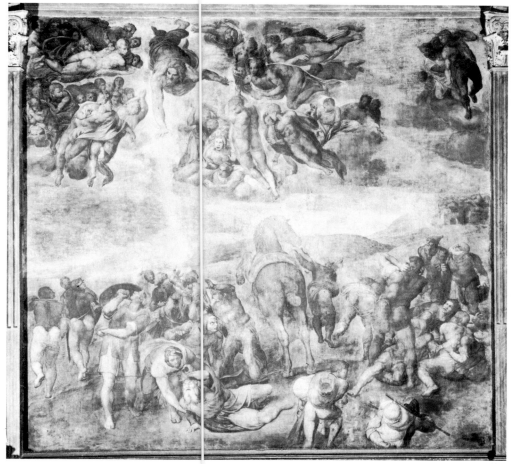

which death is not sculptured'. This then is the mood of *The Rondanini Pietà* (plate 99). It is extremely moving, with an air of unreality. The separate forms of mother and son seem to merge into one, and the rather macabre free hanging arm only adds to the feeling of mystery. It is assumed that this arm and Christ's right leg belong to an earlier version, but Michelangelo has made no attempt to remove the arm, and the body of Christ has been adapted to suit the new mood.

It is difficult to see how he could have finished it had he lived. More than any of his other works, this group has a total unity both of form and spirit. This is the 'sweet strength' that is so much the essence of his art. Here, in this one piece, he has poured out the depths of his innermost soul. Here we see the naked man.

The two figures stand, slimly elongated and just over life-size. They droop rather than sag, and almost flow onto the base. They are weightless, organically growing in and out of each other in a constant interchange of form. Michelangelo has made no attempt to make one more important than the other, and they are both equal partners in their pity. He has made a particular pity mean something more, and it is impossible not to be moved by the air of hopeless sorrow.

Plate 86
The Crucifixion of St Peter
1542–50
Fresco
20 ft 6 in × 21 ft 8 in (625 × 661 cm)
Pauline Chapel, The Vatican, Rome

Writing to Vasari on the death of his faithful assistant, Pietro Urbino, he says: 'In life he kept me alive, dying he taught me how to die, not with displeasure but with desire for death . . . he was sorry to leave me alive in this traitorous world, with so much distress . . . nothing remains for me but infinite misery.'

. . . I weep and talk and nothing now can sever
Me from my dead Urbino who, were he
Alive, might now indeed converse with me.
But he is dead, so by another way
I hope to lodge with him without delay. (from *Sonnet LXVIII*)

He is obviously preparing himself for a death he now knows is not far off; in his mood of deep religious conviction, he seems quite ready for it. There is never a hint of fear.

. . . The thorns, the nails, the wounds in both your palms
The gentleness, the pity on your face—
For great repentance, these have promised grace.
My soul will find salvation in your arms . . . (from *Sonnet LXXIII*)

In *The Rondanini Pietà* it is as though he is the dying son, sinking slowly in the arms of his mother. It is as if he carved as he died;

as he started to fail, the spirit slid a little lower.

His last poem conveys his mood:

Dear to me is sleep: still more, being made of stone.
While pain and guilt still linger here below,
Blindness and numbness—these please me alone;
Then do not wake me, keep your voices low. (*Sonnet LXXVIII*)

The long agony of Michelangelo's life was largely of his own making. To quote Dante, he 'wilfully lived in sadness'. His difficult temperament—he was the first to admit that he was his own worst enemy—and his innate melancholy, made it impossible for him to live easily. The fact that so many of his schemes came to nothing must have added to his despair, and at times he found himself in real doubt as to his abilities as an artist.

Referring to Michelangelo's melancholy, Sebastiano del Piombo wrote: 'No one can take from you your glory and honour. Think a little who you are, and remember there is no one who can do you harm but yourself.'

In a way he lived too long—'a ghost from another age'[1]—living in a world he did not really understand. He wrote of his wish to 'repose with death, with whom I seek day and night to familiarise myself, so that she will treat me no worse than other old men'.

By the world's vanities I've been distracted,
And thus have squandered hours which should have been
reserved for God. His mercy I've rejected,
and my misuse of it has made me sin.

The knowledge which makes others wise has made
Me blind. I recognise my faults too late.
Hope lessens, yet, before desires fade,
Of friend, dissolve my self-love and self-hate.

And God, divide, I beg, the road that leads
To Heaven; I cannot climb its length alone,
I need your help through all the snares and strife.

Help me to loathe the world and all its deeds;
I'll cast its beauties out but to atone,
And find the promise of eternal life. (*Sonnet LXVI*)

'You will say with truth that I am old and mad; I tell you there is no better approach to sanity and balance than to be mad'.

He died on 18 February 1564. He left his soul to God, his body to the earth and his belongings to his nearest relatives. In the moment of his death his friends were to remember the death of Christ: 'Then do not wake me, keep your voices low.'

F. Hart, *Michelangelo*, Thames & Hudson 1965, p.64.

Predecessors and Contemporaries

Always generous in acknowledging his debt to his early Florentine predecessors—in particular Giotto, Masaccio and Donatello—Michelangelo, though strictly the last of the 'Florentines', cannot be seen in isolation from his great contemporaries, Leonardo da Vinci and Raphael.

Returning briefly to Vasari's *Lives of the Artists*, it is possible to sense the underlying spirit of his art through the eyes of the man who was in many ways the first art historian in his attempts to interpret past art and to define its varying styles. Our debt to Giorgio Vasari (1511–74) is immense and whatever their individual limitations, his *Lives* are a landmark in the writing of art history.

'It goes without saying that the arts must have been discovered by some one person; and I realise that someone made a beginning at some time. And of course it is possible for one man to have helped another, and to have taught and opened the way to design, colour, and relief; for I know that our art consists first and foremost in the imitation of nature but then, since it cannot reach such heights unaided, in the imitation of the most accomplished artists. Still, I think it is very dangerous to insist that the origin of the arts can be traced to this or that person, and in any case this is hardly something we need to worry about . . . We have, after all, already seen what is the true origin and basis of art. An artist lives and acquires fame through his works; but with the passing of time, which consumes everything, these works—the first, then the second, then the third—fade away. When there were no writers there was no way of leaving for posterity any record of works of art, and so the artists themselves also sank into obscurity.'

Vasari wrote, above all, for his fellow artists.

'. . . I have been talking about the origins of sculpture and painting, perhaps at greater length than was called for at this stage. However, the reason for my doing so has been not so much my great love of the arts as the hope that I would say something useful and helpful to our own artists. . . . I hope that this work of mine, such as it is, if it proves worthy of a happier fate may, because of what I have

Plate 87
Self-Portrait of Giorgio Vasari
c. 1560
Oil on canvas
39 × 31 in (100 × 79 cm)
The Uffizi Gallery, Florence

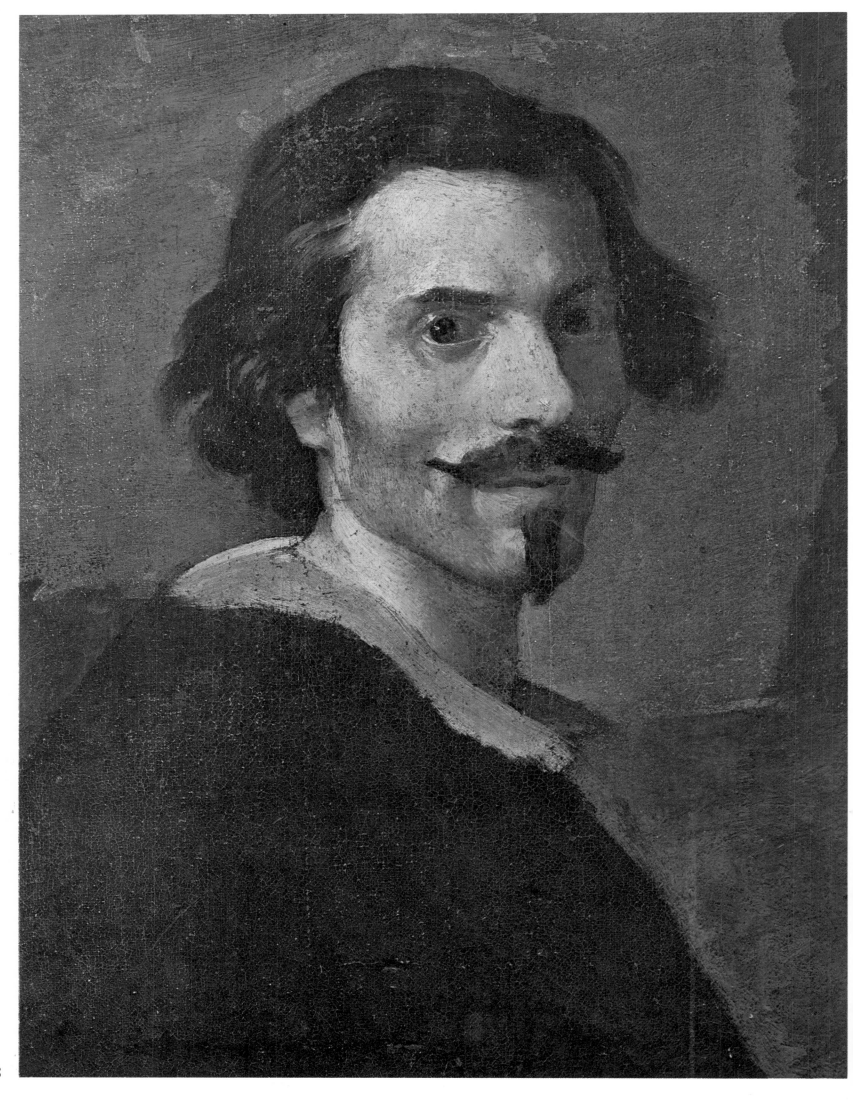

already said and what I am going to write, keep the arts alive, or at least may inspire some of the more able among us to give them every possible encouragement.'

Intending to 'distinguish between the good, the better and the best', and determined to keep alive the memory of the great artists, he obviously delighted in their personal quirks, and his vivid impressions have all the colour of the historical romance.

He judged by the standards available to him at the time, and the *Lives* are largely based on tradition handed down by word of mouth, together with hazy recollections. To these he added the art theories current in the Florence and Rome of his time.

How close he gets to the truth will always be a matter of opinion, but there is no doubt that he set himself a high standard and though at times we sense a certain carelessness in his chronology, he tells a good story and as a source is invaluable.

'. . . . My good intentions and the work of outstanding men will, I hope, provide the arts with support and adornment of a kind which, if I may be allowed to say this outright, they have been lacking hitherto.'

Vasari believed that drawing was the foundation of sound art and that a work was built up from, and around, detailed preparatory sketches or cartoons. It should be a combination of the thing seen, and the perfect form which existed in the artist's mind. He insisted that true art consisted in the imitation of nature and that this was the way to perfection. A figure must be seen to breathe. Art must be graceful and decorous, the form always appropriate to the subject: a virgin, virginal and a saint, saintly, and all their gestures should enhance the unity of the work. Form and content should be one. A particular style would be the result of the artist's judgement whilst the work was in progress and the painting or piece of sculpture an expression of his sensibility.

Vasari begins his life of **Giotto** (1266/7 or, less probably, 1276–1337): 'In my opinion painters owe to Giotto, the Florentine painter, exactly the same debt they owe to nature, which constantly serves them as a model and whose finest and most beautiful aspects they are always trying to imitate and reproduce.' Giotto it was who made the 'decisive break with the crude traditional Byzantine style and brought to life the great art of painting as we know it today, introducing the technique of drawing accurately from life, which had been neglected for more than two hundred years.'

He admires the fact that Giotto was able to paint 'with great effect the tears of a number of friars lamenting the death of St Francis', and that he was able to depict such subtleties as 'the

Plate 88
Self-Portrait of Gianlorenzo Bernini
c. 1635
Oil on canvas
26¾ × 16½ in (53 × 52 cm)
The Borghese Gallery, Rome

Plate 89
The Piazza del Campidoglio, Rome
Michelangelo's transformation of the
Capitoline Square was his most important
secular commission and was begun in 1546

Plate 90
St Peter's, Rome
This aerial photograph of St Peter's and the
Bernini colonnade was taken in 1929. The
group of buildings in the foreground was
demolished by Mussolini in 1935/36 so as
to give an uninterrupted view of the
basilica.

prompt service given by some servants at table'. He talks of the
'wonderful variety of gestures', the variations of costume and
commends not only the 'observation and imitation of nature' but
also the composition of each scene.

'One of the most beautiful scenes is of a man showing signs of
great thirst kneeling down to drink eagerly at a fountain; the
incident is conveyed so exactly and so movingly that one might be
looking at the real person.'

He constantly draws our attention to the simple human everyday
acts which are so much Giotto's strength; the simplicity of his
observation.

'The beautiful draperies and the graceful and lively heads are
both marvellous; but the outstanding feature is the remarkably
lovely young woman who is swearing on a book to refute an
accusation of adultery. Her attitudes and gestures are stupendous:
she stands there, staring straight into the eyes of her husband, who
is compelling her to declare her innocence on oath because of the
distrust aroused in him by the dark-skinned boy to whom she has
given birth, and whom he just cannot accept as his own.

Plate 91
The Central Nave, St Peter's

While her husband shows suspicion and contempt in his expression, the purity of her face and her eyes proclaim to those who are watching her so intently her innocence and her simplicity and the wickedness of the wrong that is being done in having her make her protestation and be falsely accused as a whore'.

Vasari has a fine eye for detail and he leaves us in no doubt that Giotto is concerned with the small, often incidental actions that, when incorporated into his painting, will give the work a certain extra authenticity. A figure of a servant is especially striking as 'with one hand he brushes away the flies from his leprous, stinking master, and with the other holds his nose in disgust to avoid the stench'. He stresses the great powers of expression but even in the most earthy scenes he is still able to see beauty and grace.

This awareness of grace and love of the elegant is very apparent in Vasari's own painting. Very much a Mannerist, he never lived up to the qualities that he expected in others, and though an extremely successful painter in his day, it is in his use of words that his strength obviously lies. Essentially a story-teller, his work is full of naïve eccentricities which are often charming, but there is little formal understanding beneath the surface.

He is particularly perceptive in his appraisal of **Masaccio** (1401 – *c.* 1428), whom he sees as a man of 'outstanding creative talent' and one who 'learnt so much from his endless studies that we are especially indebted to him for the good style of modern painting.' Fully understanding the formal importance of Masaccio's contribution, he tells us that he 'introduced many new techniques and made his foreshortenings, which he painted from every angle, far better than any done before' and that 'his paintings were remarkably soft and harmonious, and he matched the flesh tints of his heads and nudes with the colours of his draperies, which he loved to depict with a few simple folds just as they appear in life. All this has been of great benefit to later artists, and indeed Masaccio can be given the credit for originating a new style of painting; certainly everything done before him can be described as artificial, whereas he produced work that is living, realistic, and natural.'

Vasari reminds us that Masaccio made more use than other artists of the nude – there is a 'superbly naked man shivering with cold' – and, almost as an aside, mentions that 'one day Michelangelo and I had been studying his (Masaccio's) work and he praised it very highly.' Here is the authentic voice straight from the horse's mouth, as it were. We know that Michelangelo worked in the Brancacci Chapel.

'There are still some heads to be seen here which are so beautiful

and lifelike that one can say outright that no other painter of that time approached the modern style of painting as did Masaccio. . . . How true this is is shown by the fact that all the most renowned sculptors and painters who have lived from that time to this have become wonderfully proficient and famous by studying and working in that chapel. . . .' He lists the artists, ending significantly with 'the inspired Michelangelo Buonarroti.'

In the life of **Filippo Brunelleschi** (1377–1446) he dwells at length, and somewhat romantically, on the architect's attempts to construct the massive dome for Florence Cathedral. Essentially an impressive engineering feat of great structural ingenuity, to Vasari it is sheer poetry and again he is very much the forerunner of later architectural philosophers: '. . . . it can be confidently asserted that the ancients never built to such a height nor risked challenging the sky itself, for it truly appears that this building challenges the heavens, soaring as it does to so great a height that it seems to measure up to the mountains around Florence. Indeed, the heavens themselves seem to be envious of it since every day it is struck by lightning.'

Gross over-exaggeration, of course, but who can deny that the picture Vasari conjures up with his excesses evokes all the splendour of what was then an almost superhuman achievement? However much we talk of structural innovations and solutions to vexing architectural problems, in the end the dome we see is Vasari's—or rather Brunelleschi's. He tells us that Brunelleschi, commenting on San Lorenzo, some ninety years before Michelangelo inherited it, suggested that it should be a church 'worthy of the district and the noble families who will have their tombs there' and Vasari ends with the rather sly comment that 'whoever wants to leave a memorial to himself should complete it while he is still living.'

Donatello (*c.*1386–1466) possessed 'such excellent qualities of grace and design that it was considered nearer what was done by the ancient Greeks and Romans than that of any other artist', and that he had the skill to produce 'sculptures of unusual beauty'. Vasari even goes as far as to admit that he was 'superior not only to his contemporaries but even to the artists of our own time'.

There is no record of what Michelangelo might have thought about that!

'He created a masterly flow of folds and curves in the draperies suggesting the form of the nude figures and showing how he was striving to recover the beauty of the ancients, which had been lost for so many years. He displayed such skill and facility that, to put it briefly, no one could have bettered his design, his judgement,

Plate 92
The Dome of St Peter's

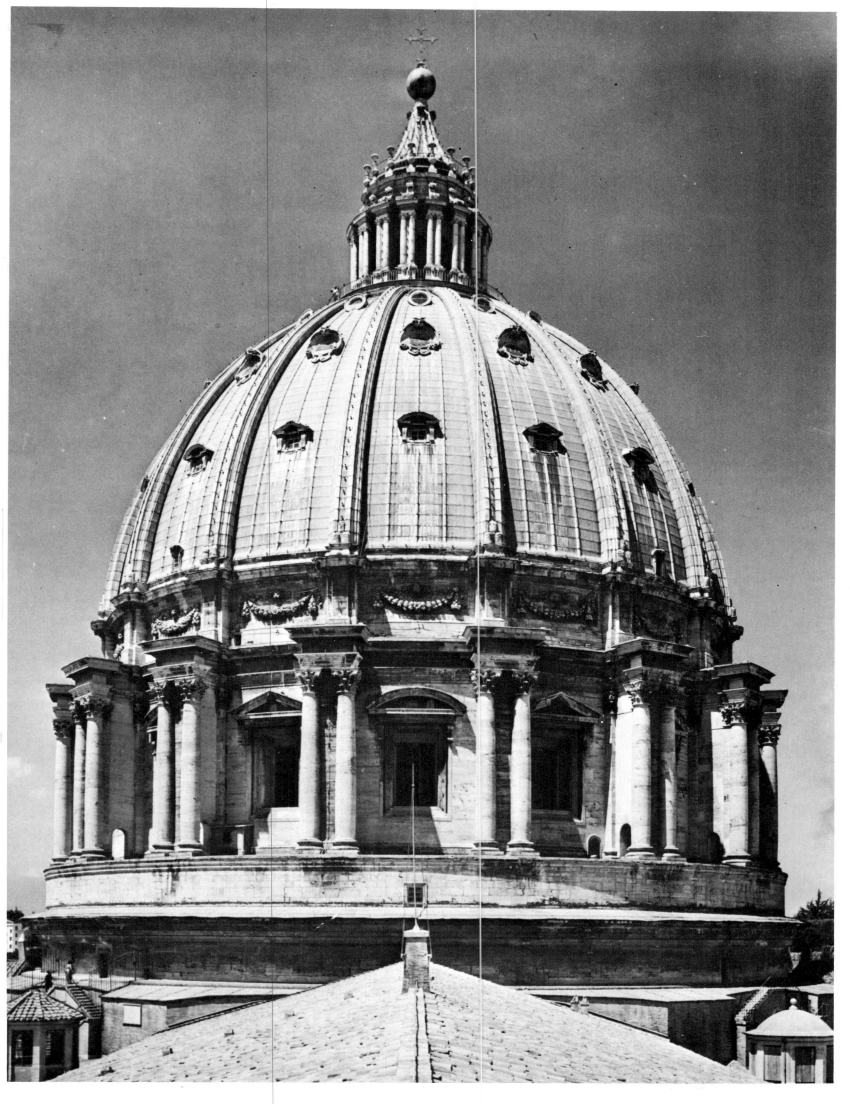

Plate 93
The Florentine Pietà
c. 1547–55
Marble
Height 7 ft 8 in (234 cm)
Florence Cathedral

Plate 94
Nicodemus
Detail from The Florentine Pietà

his use of the chisel, or his execution of the work'.

Nearly all sculpture owes a debt to Donatello and what to Vasari was a style 'saturated in the spirit of antiquity', is to our eyes almost expressionistic in its insight into human emotions, though there is undoubtedly a slightly larger-than-life feel about it which we associate most readily with Greece and Rome.

He tells us that Donatello left his professional belongings to his pupil, Bertoldo di Giovanni, who later supervised the Medici 'sculpture school' to which the young Michelangelo went on leaving the Ghirlandaio workshop. The life of Donatello ends rather cryptically with, 'Either the spirit of Donatello moves Buonarroti, or that of Buonarroti first moved Donatello.'

The essence of Michelangelo is certainly to be found in the work of his predecessors, particularly in the naturalism of Giotto and Masaccio and in the subtly expressive forms of Donatello, and Vasari's *Lives* are our evidence. They give us clearly the spirit of the past as well as the form and nothing written since has given us any cause to disagree, except in detail, with his interpretations. The sweetness and strength of Michelangelo are surely characteristics of the spirit.

Of his contemporaries two men stand head and shoulders above all others, Leonardo da Vinci and Raphael. Together they represent the very highest peak of the Italian High Renaissance.

Leonardo da Vinci (1452–1519) had a 'disposition so lovable that he commanded everyone's affection. He owned, one might say, nothing and he worked very little, yet he always kept servants as well as horses. These gave him great pleasure, as indeed did all the animal creation, which he treated with wonderful love and patience when he was walking past the places where birds were sold he would pay the price asked, take them from their cages and let them fly off into the air, giving them back their lost freedom.' Immediately Leonardo's art takes on a new gentleness, the man of science is human after all, the arch intellectual is capable of the most sentimental feelings.

Vasari is equally perceptive in saying that 'clearly it was because of his profound knowledge of painting that Leonardo started so many things without finishing them; for he was convinced that his hands, for all their skill, could never perfectly express the subtle and wonderful ideas of his imagination.' He completely captures the spirit of Leonardo in his description of the *Mona Lisa*.

'For Francesco del Giocondo Leonardo undertook to execute the portrait of his wife, Mona Lisa. He worked on this painting for four years and then left it still unfinished. If one wanted to see how

faithfully art can imitate nature, one could readily perceive it from this head; for here Leonardo subtly reproduced every living detail. The eyes had their natural lustre and moistness, and around them were the lashes and all those rosy and pearly tints that demand the greatest delicacy of execution. The eyebrows were completely natural, growing thickly in one place and lightly in another and following the pores of the skin. The nose was finely painted, with rosy and delicate nostrils as in life. The mouth, joined to the flesh-tints of the face by the red of the lips, appeared to be living flesh rather than paint. On looking closely at the pit of her throat one could swear that the pulses were beating. Altogether this picture was painted in a manner to make the most confident artist— no matter who—despair and lose heart. Leonardo also made use of this device; while he was painting Mona Lisa, who was a very beautiful woman, he employed singers and musicians or jesters to keep her full of merriment and so chase away the melancholy that painters usually give to portraits. As a result, in this painting of Leonardo's there was a smile so pleasing that it seemed divine rather than human; and those who saw it were amazed to find that it was as alive as the original.'

The painting, incidentally, left Italy for France in 1517. Vasari born in 1511, never went to France.

Kenneth Clark adds to the enigma:

'How exquisitely lovely the Mona Lisa must have been when Vasari saw her; for of course his description of her fresh rosy colouring must be perfectly accurate. She is beautiful enough even now, heaven knows, if we could see her properly. Anyone who has had the privilege of seeing the Mona Lisa taken down, out of the deep well in which she hangs, and carried to the light will remember the wonderful transformation that takes place. The presence that rises before one, so much larger and more majestical than one imagined, is no longer a diver in deep seas. In the sunshine something of the warm life which Vasari admired comes back to her, and tinges her cheeks and lips, and we can understand how he saw her as being primarily a masterpiece of naturalism. He was thinking of that miraculous subtlety of modelling, that imperceptible melting of tone into tone, plane into plane, which hardly any other painter has achieved without littleness or loss of texture'.[1]

We can only assume that Vasari talked to someone who had seen the painting, but in the end it matters very little, and despite what we may feel about the perpetuation of the Mona Lisa myth, and in spite of our determined objectivity, we see all the mystery and glamour that we find impossible to deny. Having convinced

Plate 95
The Palestrina Pietà
c. 1556
Marble
Height 8 ft 2½ in (205.5 cm)
Accademia, Florence

[1] Kenneth Clark, *Leonardo da Vinci*, Penguin 1961, p.111.

118

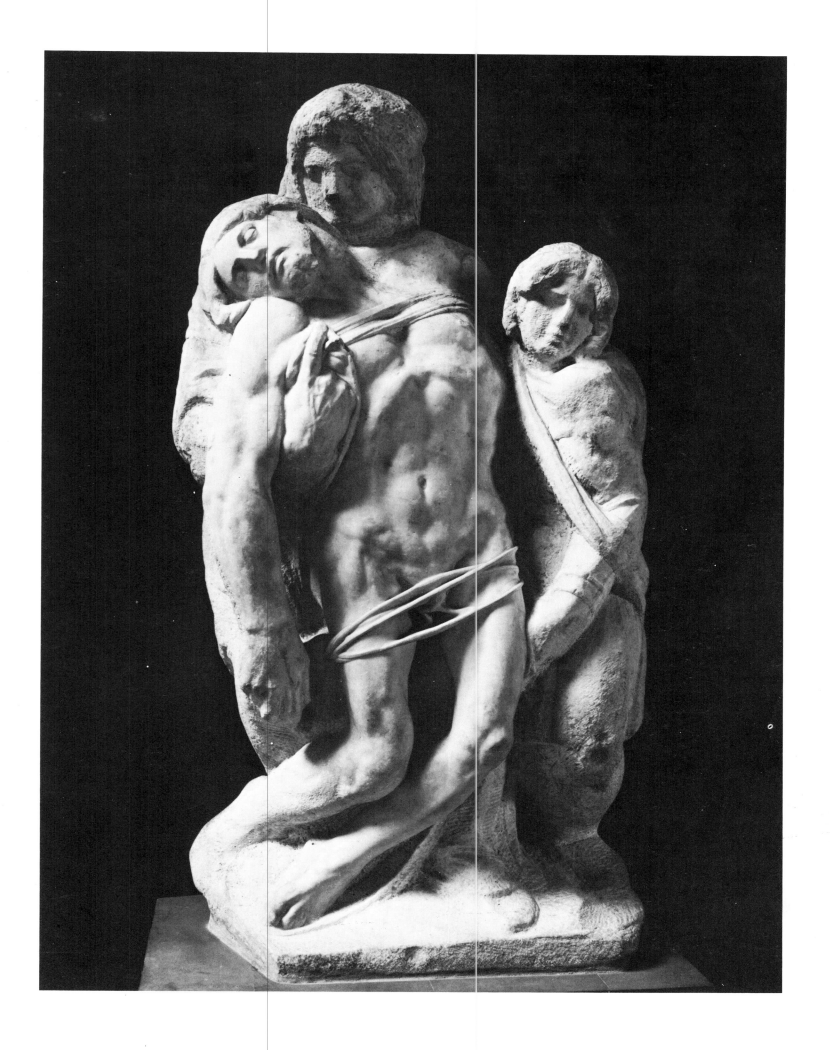

Plate 96
Christ on the Cross between the Virgin and St John
*c.*1550–56
Black Chalk
15¾ × 8⅝ in (40 × 22 cm)
Royal Library, Windsor (Inventory No. 12761)

Plate 97
Christ on the Cross between the Virgin and St John
c. 1540
Black chalk
11 × 9.2 in (27.9 × 23.4 cm)
Ashmolean Museum, Oxford

us of Leonardo's worldliness and extreme sensibility, Vasari, with typical irresponsibility, then tells us that he and Michelangelo 'strongly disliked each other'.

Of all Michelangelo's contemporaries it is **Raphael of Urbino** (1483–1520), 'the most graceful of all, who studied what had been achieved by both the ancient and the modern masters, selected the best qualities from all their works, and by this means so enhanced the art of painting that it achieved a faultless perfection', who comes closest to equalling his great achievements. Vasari is rightly unstinting in his praise:

'Nature sent Raphael into the world after it had been vanquished by the art of Michelangelo and was ready, through Raphael, to be vanquished by character as well. Indeed, until Raphael most artists had in their temperament a touch of uncouthness and even madness that made them outlandish and eccentric; the dark shadows of vice were often more evident in their lives than the shining light of the virtues that can make men immortal.' He goes on, 'One can claim without contradiction that artists as outstandingly gifted as Raphael are not simply men but, if it be allowed to say so, mortal gods'

Amusingly, he states that Raphael's father 'also understood how important it was that children should be reared on the milk of their own mothers, rather than wet-nurses'—a dig at Michelangelo perhaps—and that he 'insisted that Raphael be suckled by his own mother.'

Raphael came first to Florence to see the Leonardo and Michelangelo cartoons for the ill-fated decorations for the Council Chamber in the Palazzo Vecchio: in Michelangelo's case, his *Battle of Cascina*. The drawings were a revelation to him, and according to Vasari, he was 'determined to settle in the city'. There is no doubt that, especially towards the end of his short life, he came to owe a great deal to Michelangelo.

Though the Life of Raphael of Urbino is one of the least successful of the *Lives*, due largely to the fact that his flamboyant literary style was ill-suited to the calm serenity of the works he was trying to describe, Vasari is particularly astute as an art historian.

He tells us that 'Raphael rid himself completely of the burden of Pietro's manner to learn from the work of Michelangelo a style that was immensely difficult in every particular; and he turned himself, as it were, from a master into a pupil once more.' Pietro Perugino (*c.* 1445–1523) had been Raphael's early master.

With great insight he realised that he could never rival the accomplishments of Michelangelo and consequently he 'resolved to emulate and perhaps surpass him in other respects'. He decided not

to waste his time by trying to imitate Michelangelo's style and, very much to the point, Vasari says: 'His example might well have been followed by many contemporary artists who, because they have confined themselves to studying the works of Michelangelo, have failed to imitate him or reach his standard of perfection; if they had followed Raphael, instead of wasting their time and creating a style that is very harsh and laboured, that lacks charm and is defective in colouring and invention, they would be aiming at a catholic excellence and trying to become proficient in other fields of painting, have benefited themselves and everyone else.'

There is no doubt that **Gianlorenzo Bernini** (1598–1680), born thirty-four years after Michelangelo's death, is his true heir and not the clumsy Sebastiano del Piombo to whom he gave his drawings to copy. Though born in Naples, Bernini is essentially Roman, virtually the creator of Roman Baroque, as well as its greatest exponent, and the only Italian to approach Michelangelo in his complete mastery of sculptural and architectural form. Though he rejected the concept of sculpture being dependent on the block from which it was carved, preferring his figures to break loose and move towards the spectator, he was a superb technician – perhaps the finest of them all – and well aware of the possible 'painterly' effects inherent in near translucent marble. The painting of his time very definitely derived from Raphael's late emotionally illustrative manner.

Sebastiano del Piombo (c. 1485–1547) came from Venice, and after working with Raphael, with whom he seems to have quarrelled, he turned openly to Michelangelo as his source of inspiration. He was happy to work from drawings he was given to copy and made no real attempt to evolve his own style. The result was a series of excessively muscular figure compositions, which though not without a certain capability, have nothing of the qualities he so obviously admired.

While Michelangelo was working in the Sistine Chapel, Raphael was decorating the Stanza della Segnatura. The frescoes included *The School of Athens* and *The Disputa*, arguably the finest examples of High Renaissance painting and certainly comparable with *The Rome Pietà*.

'As well as the many fine details with which Raphael expressed his ideas, one must remark on the composition of the entire scene; for it is convincingly arranged with such order and proportion that by the genius shown in this work Raphael clearly demonstrated his determination to be the undisputed master among all those using the brush.'

The Rome Pietà is, after all, sculpture.

Plate 98
Crucifix
1492–1493
Wood, painted
Height 53 in (135 cm)
Santo Spirito, Florence
This remarkable Crucifix was discovered in 1963 in the Augustinian Priory of Santo Spirito, Florence. It is the only known work by Michelangelo executed in wood, and it seems that he was unable to find a block large enough to complete the whole figure, so that both arms and portions of the legs and also the face are pieced. The figure is reminiscent of classical Hellenic nudes in its grace and beauty, and no attempt has been made to show the pain and sorrow normally associated with The Crucifixion.

Plate 99
The Rondanini Pietà
c. 1552–64
Marble
Height 6 ft 3⅝ in (190.5 cm)
Castello Sforzesco, Milan

Plate 100
Study for the Risen Christ
c. 1533
Black chalk
16⅛ × 10¾ in (41.4 × 27.4 cm)
British Museum

Vasari is at pains to explain the 'enmity' between Raphael and Michelangelo, or rather between Michelangelo and Raphael. He tells us the following story: 'By now Raphael had made a great name for himself in Rome. He had developed a smooth and graceful style that everyone admired, he had seen any number of antiquities in that city and he studied continuously; none the less, his figures still lacked the indefinable grandeur and majesty that he now started to give them.' He goes on, 'Bramante, who had the keys of the chapel, being a friend of Raphael brought him to see Michelangelo's work and study the technique.' He concludes: 'When Michelangelo later saw Raphael's work he was convinced, and rightly, that Bramante had deliberately done him wrong for the sake of Raphael's reputation and benefit.'

Knowing Michelangelo's difficult temperament and allowing for what almost amounted to persecution mania, it must always be remembered that Vasari conceived the *Lives*—and indeed all art history—as a prelude to the work of his beloved Michelangelo and throughout is unwavering in his loyalty. Vasari is in no doubt that Michelangelo Buonarroti is the greatest of them all.

'But the man whose work transcends and eclipses that of every other artist, living or dead, is the inspired Michelangelo Buonarroti, who is supreme not in one art alone but in all three. He surpasses not only all those whose work can be said to be superior to nature but also the artists of the ancient world, whose superiority is beyond doubt. Michelangelo has triumphed over later artists, over the artists of the ancient world, over nature itself, which has produced nothing, however challenging or extraordinary, that his inspired genius, with its great powers of application, design, artistry, judgement and grace, has not been able to surpass with ease. He has shown his genius not only in painting and colouring (in which are expressed all possible forms and bodies, straight and curved, tangible and intangible, accessible and inaccessible) but also in the creation of sculptural works in full relief. And his fruitful and inspiring labours have already spread their branches so wide that the world has been filled with an abundance of delectable fruits, and the three fine arts have been brought to a state of complete perfection. He has so enhanced the art of sculpture that we can say without fear of contradiction that his statues are in every aspect far superior to those of the ancient world. For if their work were put side by side, the heads, the hands, arms and feet carved by Michelangelo being compared with those made by the ancients, his would be seen to be fashioned on sounder principles and executed with more grace and perfection: the effortless intensity of his graceful style defies comparison.'

Bibliography

Ludwig Goldscheider, *Michelangelo: Paintings, Sculptures, Architecture*, Phaidon, 1967 (5th ed.)

Elizabeth Jennings, (translator) *The Sonnets of Michelangelo*, Allison & Busby, 1969

Kenneth Clark, *The Nude*, John Murray, 1967

Giorgio Vasari, *Lives of the Artists*, Penguin, 1970

Adrian Stokes, *Michelangelo*, Tavistock Publications, 1955

Ayrton, Michael, *Rudiments of Paradise*, Secker & Warburg, 1971

Acknowledgments

Reproduced by gracious permission of Her Majesty the Queen: 120–121.

Colour Plates: Metropolitan Museum of Art, New York 61 right; The National Gallery, London 6, 84, 100; Scala, Florence, frontispiece 8, 9, 13, 14, 24, 31, 32, 34, 35, 36, 37, 38, 39, 41, 44–45, 46, 47, 48–49, 50–51, 52, 53, 54–55, 56, 59, 60–61, 62–63, 64, 65, 66–67, 68, 73, 76, 77, 88, 89, 91, 92, 94, 95 top left, 97, 99, 103 right, 104, 107, 108, 110, 112, 124 left.

Black and white illustrations: Ashmolean Museum Oxford, 120–121 right; Courtauld Institute of Art, London 26; Hamlyn Group Picture Library, 69; Mansell Collection, London 124–125; Mansell–Alinari Collection, London 11, 12, 20, 21, 22, 23, 27, 28, 42, 70, 71, 74, 78, 80 top, 86, 87, 88, 90, 95 bottom, 98, 102 left, 116, 117, 119; Leonard von Matt 10, 16, 17, 72, 79, 80 bottom, 85, 115; Arnoldo Mondadori, Milan 33; Scala, Florence 89, 92, 102 right, 103 left, 103 right, 104, 107, 124 left.

Cambridge University Press: From *Leonardo da Vinci* by Kenneth Clark. Reprinted by permission.

Penguin: From *Lives of the Artists* by Giorgio Vasari. Reprinted by permission.

Index

Index

1